CARVING
THE CIVIL WAR

WITH TOM WOLFE

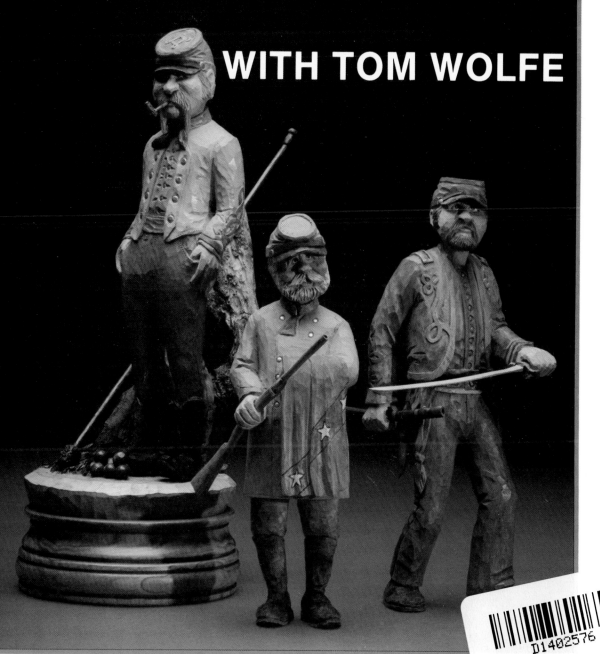

Schiffer Publishing Ltd

1469 Morstein Road, West Chester, Pennsylvania 19380

Published by Schiffer Publishing, Ltd.
1469 Morstein Road
West Chester, Pennsylvania 19380
Please write for a free catalog.
This book may be purchased from the publisher.
Please include $2.00 postage.
Try your bookstore first.

We are interested in hearing from authors
with book ideas on related subjects.

Contents

Introduction . 3
The Patterns . 5
Carving the Soldier . 10
Painting the Soldier . 49
A Civil War Gallery . 56

Introduction

I was raised in West Virginia, and my great grandfather was raised and buried in Kentucky. One time I asked one of my uncles if Grandpa fought during the Civil War. He said he was too young to fight. He was only ten or eleven years old, but he carried water to the soldiers. Back then carrying water to the battle field was a good way for a kid to earn a little extra money. His dad, my great great grand-daddy, was killed during the Civil War. From what we know by hearing people talk down through the years he is buried somewhere in Pennsylvania, but nobody seems to know where. He was probably fighting with the South and was killed in Pennsylvania, maybe at Gettysburg.

The reason we aren't sure which side he was on is that in West Virginia and all through the Appalachians the mountain people thought so little about the actual fighting that they fought both ways. During the war, West Virginia seceded from Virginia to join Maryland as a neutral state.

That didn't keep West Virginia out of the war. After Fort Sumter, the first land battle of the Civil War was in West Virginia. There were fifty-five skirmishes there, which makes it one of the states with the heaviest fighting. Most of the actual fighting was done along the trough that went from Tennessee into Pennsylvania which separates the Blue Ridge Mountains and the Appalachians.

The area we live in now in Blowing Rock was in North Carolina, so it was in a Confederate state. But the people of Blowing Rock and all of the other Appalachian areas in the heavy mountains were mostly Union sympathizers. They didn't have and keep slaves, they weren't in the cotton business, they weren't in the farm business, and they weren't plantation owners. When they fought with the South it was usually because they were conscripted by the Confederacy, often against their will. Their sympathies were with the North, but not enough to go and join the army and fight for the North.

But not everyone who was drafted went to war. In the area of Blowing Rock there is a place called Howard's Knob. Howard's Knob has a lot of caves and rock overhangs, and during the Civil War half of the men who didn't want to fight for the South would hide in those rocks. I asked one of my uncle's one time if any of our people had died during the Civil War. He said, "Yes, we had one who died during the Civil War." I asked, "Where was he killed at?" He said, "He wasn't killed. He hid out in a cave to keep from going to war, caught pneumonia, and died."

Others took part in the war in their own way. There's a book recently written that gathers some of the stories of the high country during the Civil War. Most of the fighting that took place there was mostly through acts of terrorism. If you were a Union sympathizer and somebody else was a Southern sympathizer, that would be a good reason to steal from him, or kill the cattle needed, or vice versa.

According to court history, it seems this old woman was in court where her son was on trial for shooting someone. The judge asked her, "Lady, did you raise your sons to act like this, to just go around and kill people?" She said, "No sir. I taught my sons to be God fearin'. I taught my sons not to lie, not to cheat, and not to steal. And I taught my sons to die like a damn dog, with their teeth right around the throat."

But, all in all, the high country was a relatively safe area during the war. A lot of people from the North and the South would take their families into the Appalachians to keep them out of harms way, because there wasn't a lot of fighting going on in the mountains of North Carolina. Blowing Rock was a resort town that started during the Civil War. After the war soldiers went back to get their families. They liked the area so well that they stayed, helping to settle the area a little bit.

There is a story about a little town named Montezuma, about twenty miles from Blowing Rock. One Montezuma man, who was conscripted by the Confederacy to fight, was more of Union sympathizer than a Southern sympathizer. But when he was drafted he went. He was newly married and his wife didn't want him to leave. She dressed up like a man and joined the army as his brother. The army allowed brothers to stay together, which was apparently worth the risk. After they were in the army for a while, though, the man took his clothes off and rolled in some poison ivy. This, of course, gave him a ghastly appearance, which was just what he wanted when he went to see his commander, General Vance. He told the general that he had a real contagious disease and that he was dying. Vance immediately gave him a discharge out of the army. Soon afterwards, his wife went to Vance and told him that she wasn't his brother, but his wife. Vance didn't believe her, so she proceeded to take off her clothes and prove to him, beyond a shadow of a doubt, that she was a woman not a man. She got her discharge.

Over the years I have spent a good deal of time in South Carolina. In fact I still have a place down there, where we go when we get the chance. In South Carolina and throughout the South stories of the Civil War are still told often. One fellow that I knew pretty well down there, old Charlie Sadler, who was a real good historian. You could ask him questions, and he would, more likely than not, know the answer. He used to tell me stories about the Civil War times.

One of them in particular was about the part of Sherman's march that went from Charleston to Columbia, South Carolina. As he went he would burn plantations, with their big old Georgian houses. But there are quite a few that are still standing. One time I asked Charlie why Sherman burned some of the houses and not others. He said that the people learned that if a house had the Masonic symbol on the front door, that Sherman wouldn't

burn the house. This news traveled faster than Sherman, so many houses were saved by a little paint. It is not understood exactly why this is. Sherman was not a Mason. In fact he was Catholic and belonged to the Knights of Columbus. Perhaps he didn't want history to accuse him of being a bigot.

One of the houses that was burned was a plantation on the Santee. Sherman's troops burned the house and took the old fellow that owned the plantation, tied him behind a caisson, and marched and dragged him twenty miles to what was called Eutaw Plantation at Eutawville. There they put him in a room and locked him up.

The man didn't know what was going on, but he figured they were going to kill him. They left him there for eight days, locked in a room without food or water. At the end of that time they must of forgotten him and left. The slaves came and turned him loose, and he went back home. Every year on the day that his ordeal happened, he would walk that twenty miles, have them lock him up in that same room in the plantation house for the same period of time, so that he would never forget to hate the Yankees.

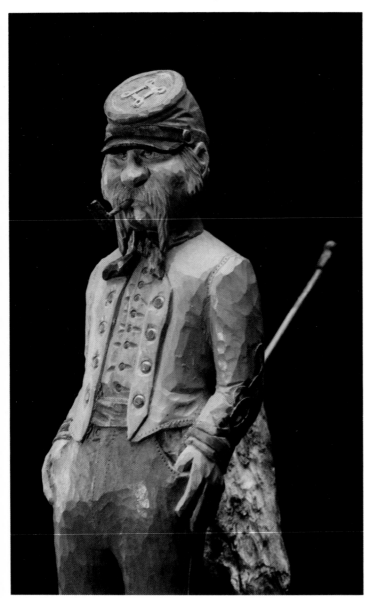

Another story that comes to mind is kind of eery. I have another friend who lives in South Carolina whose wife made a quilt. After she had completed the quilt one of her great aunts died and she was left some stuff from the old house and home place. One of the things she was left was a quilt. According to the family history, this quilt was used to wrap the silverware and bury it when Sherman was coming. After Sherman's army was gone they went back and dug it up. This old quilt had been wrapped in a blanket in the attic of the house, and my friend's wife had never seen it before in her life. When she got this quilt and unwrapped it she couldn't believe her eyes. She displayed side-by-side with the quilt she had made and they were identical. Even down to the small inch-and-a-half octagon pieces, the same overall designs, the same overall patterns, the same overall sizes of the pieces, and even the same colors of the pieces were the same. And while the little prints were different, they were the same color and size. The quilt looks like it was made by the same person that made the quilt a hundred-fifty years ago.

When I envisioned the main character of this book, I thought about a soldier going home from the war. He is defeated but not beaten. He still has his dignity, his family, and his ideals intact.

One story about the Civil War involves a Confederate soldier returning home after the war, to somewhat different circumstances. Before he went home he stopped in the town near where he lived. He met one of his old field hands who had worked with him for years and years.

"Joe, how have things been going at the house?" he asked.

"Well, things have been goin' pretty good, Cap'n," he said. "Not too bad."

"Anything happen while I was gone?"

"Oh, Ol' Jack, your favorite dog, died."

"He did?"

"Yeah, he died."

"What killed him?"

"Well, he ate poisoned meat."

"How did he get hold of poisoned meat? How did it happen?"

"Well, your horse died and we drug him out, he rotted, and the dog ate the bad meat and died."

"How did the horse die?"

"Well, he died when the barn burnt."

"You mean my barn burnt?"

"Yessir, Cap'n, the barn burnt down."

"How did the barn burn down?"

"Sparks from the house."

"You mean the house burned down too?"

"Yessir, Cap'n."

"What caught the house on fire?"

"Shroud curtains caught on fire from the candles at the wake."

"What wake?"

"Well, your momma-in-law died of heart failure."

"How come she died of heart failure. She was a pretty strong ol' woman."

"Well, she died when your wife ran off with that Yankee."

The Patterns

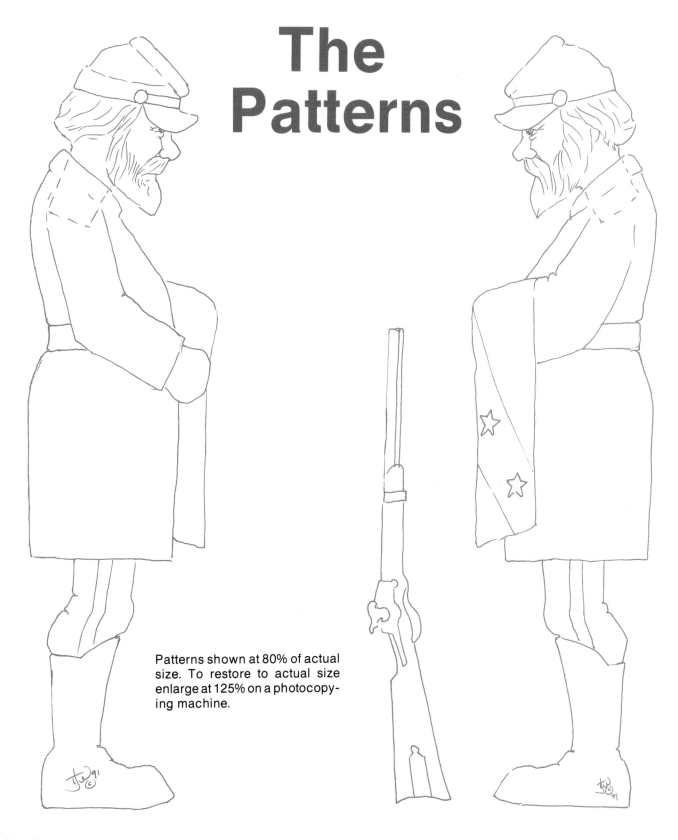

Patterns shown at 80% of actual size. To restore to actual size enlarge at 125% on a photocopying machine.

The Tools and Patterns

The tools needed for this project include a simple set of palm gouges, a turned-down blade and a turned-up blade, and some eye punches or nailsets for the eyes and buttons. The wood I use is bass, and it is probably the best for these figures. It carves and takes the paint nicely.

The patterns are reproduced at a percentage of their actual size as indicated with each pattern. You may use them as they appear or enlarge or reduce them on a photocopying machine. I have included an enlargement percentage to get them back to their original size. While you are at the copying machine, print several copies so you can cut them apart as needed to help in the drawing of the various parts.

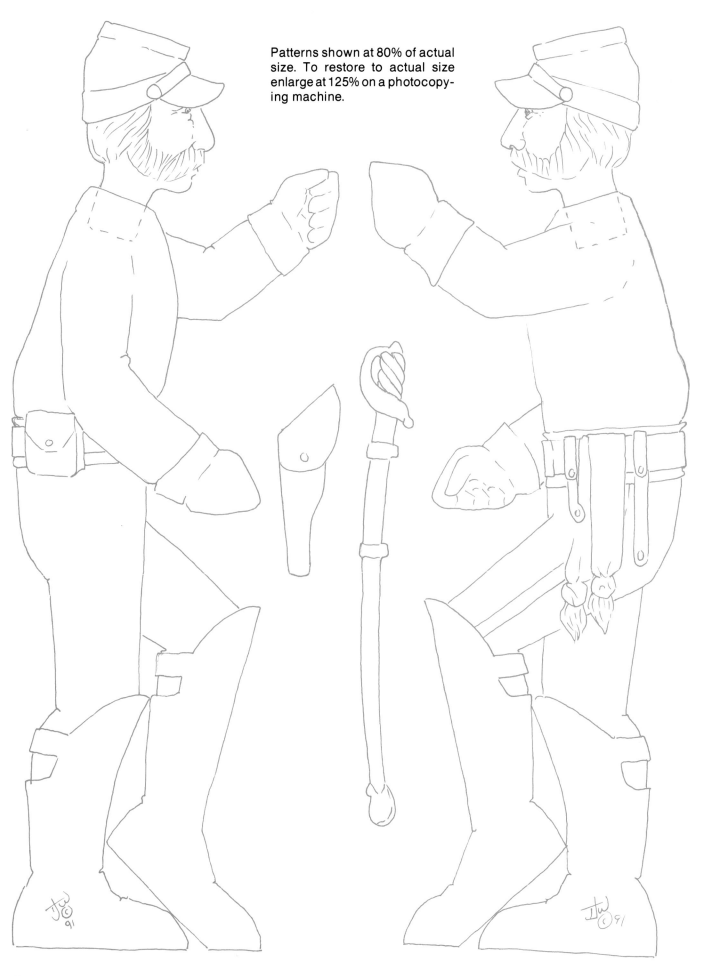

Patterns shown at 80% of actual size. To restore to actual size enlarge at 125% on a photocopying machine.

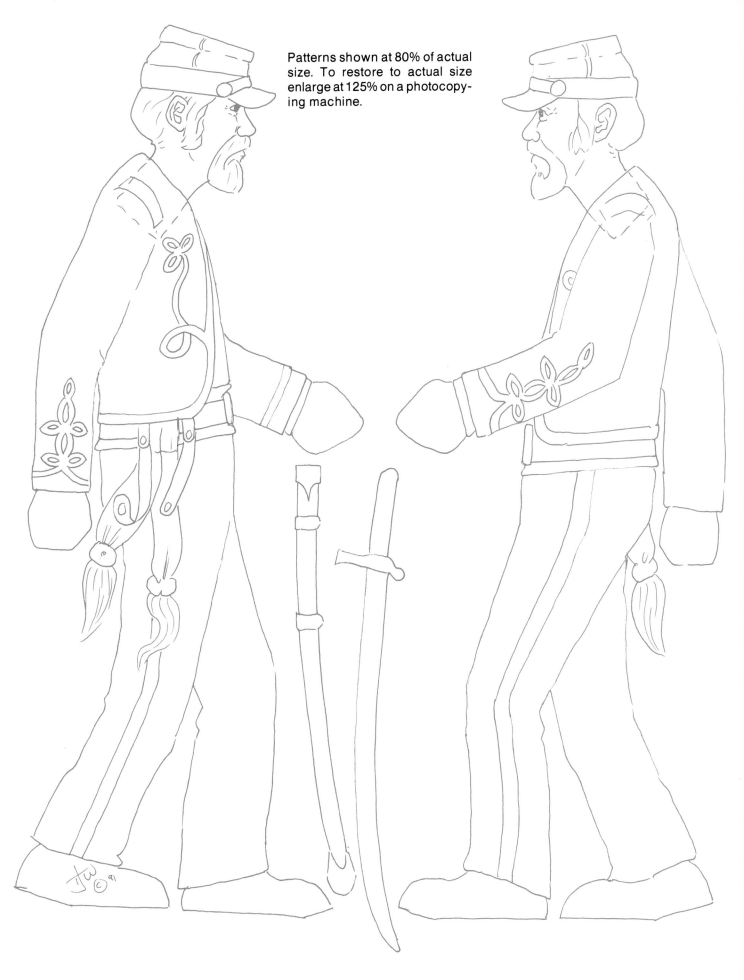

Patterns shown at 80% of actual
size. To restore to actual size
enlarge at 125% on a photocopy-
ing machine.

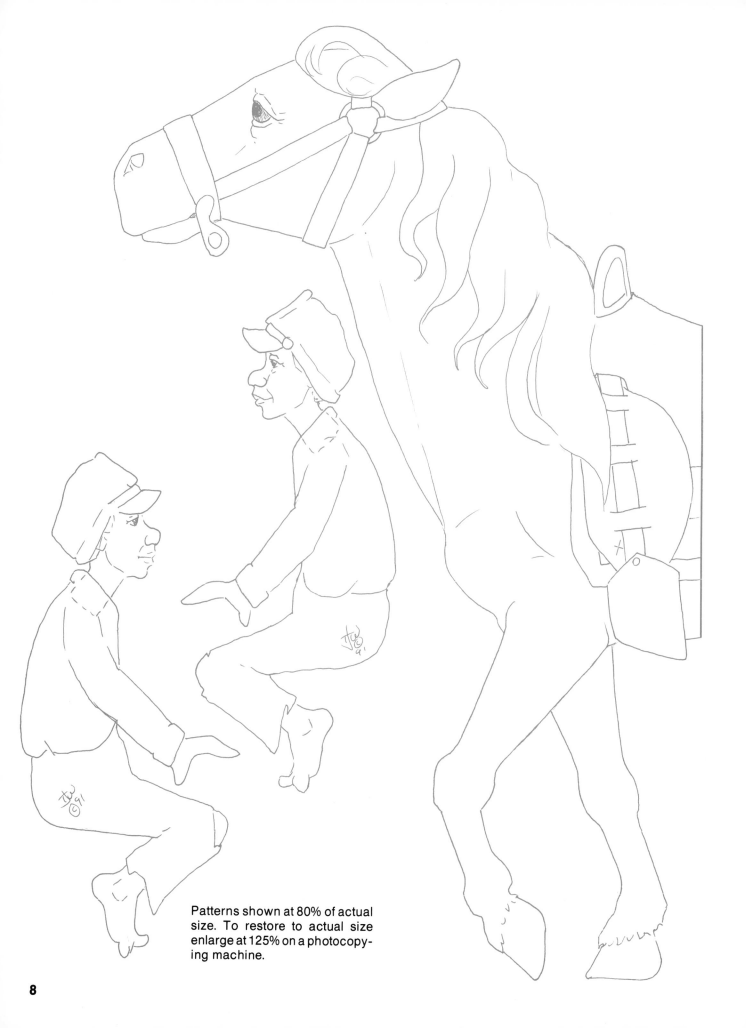

Patterns shown at 80% of actual size. To restore to actual size enlarge at 125% on a photocopying machine.

Carving the Soldier

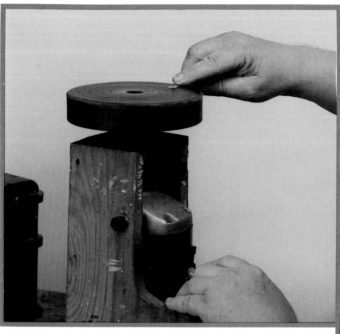

Always begin with sharp tools. I use a diamond impregnated rubber wheel with a leather disc glued to the top to get a sharp finish. It is mounted on a reversible drill held in a wooden frame. I apply a jeweler's rouge to the leather to get the abrasive quality that hones the sharp edge I need.

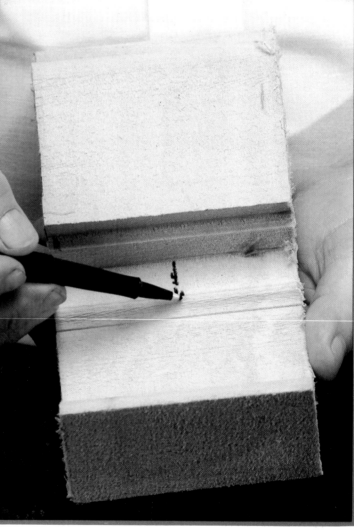

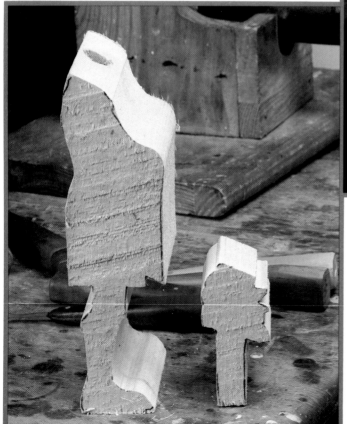

Mark the front and back of the blank. Do this freehand. Because each piece of wood will differ, this will save frustration and wood, and you'll probably end up with a better looking piece. I have ruined more pieces trying to follow a front pattern than I care to remember. It also gives you the freedom to work around blemishes in the wood. Find the center...

Cut out the blanks on a bandsaw.

mark it and make a bow on the inside of the legs.

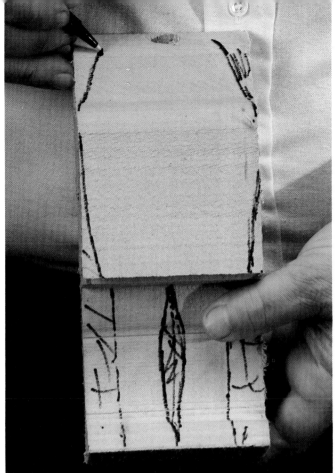

Mark the area to be removed, and draw in the shape of the shoulder.

Return to the bandsaw and trim away the excess, creating the overall shape of the body.

This knot might give me some trouble...

so I'll draw the pattern to keep it out of the way.

Drill a hole for the neck. Pick a drill bit that matches the thickness of the neck on the head pattern. Because drill bits come in different sizes it is better to go from the neck to the drill bit rather than vice versa. It is also better not to have a set size, in case you enlarge or shrink your pattern size.

Using a knife, round and shape the neck.

Work your way down both sides, removing all the excess.

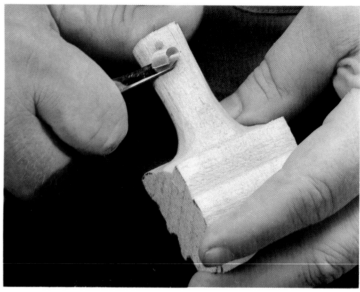

When you get the neck rounded, begin to taper it toward the bottom. It needs to taper enough to fit in the hole you have drilled in the body.

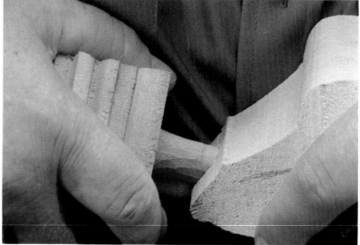

Place the neck in the hole and apply pressure while turning it.

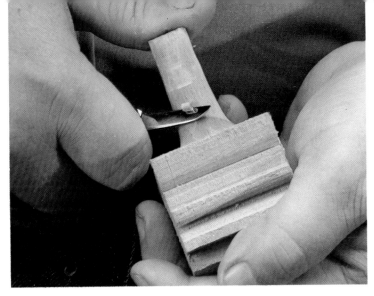

When you remove the head you will see shiny spots where the neck needs further trimming. Repeat this process until you have a nice snug fit.

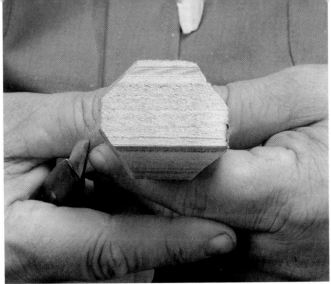

You should end up with an octagonal shape when viewing the head from the top.

We will leave the neck long for now and continue carving the head.

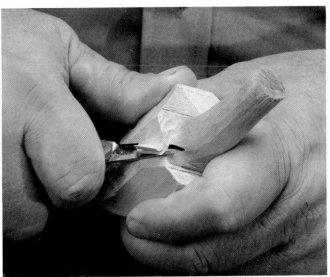

Taper the sides of the head toward the jaw line.

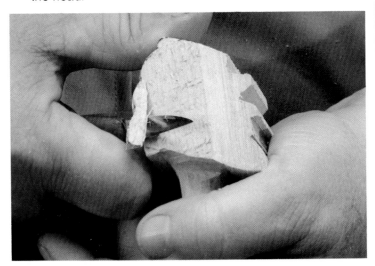

Remove the four corners of the head. Because you are going with the grain, these should pry right off with the knife.

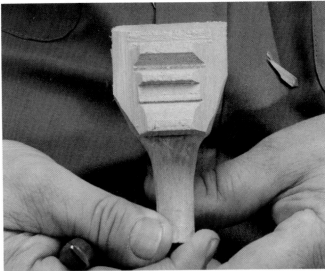

Continue tapering the head until you reach this general shape.

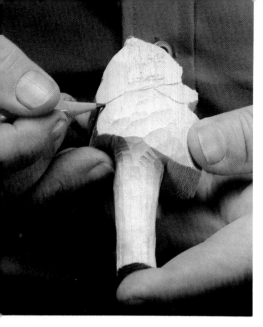

Draw in the lines of the kepi.

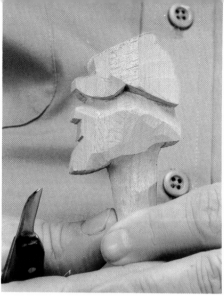

Continue to bring out the shape of the kepi by trimming the head back to and under it.

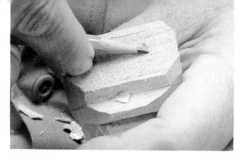

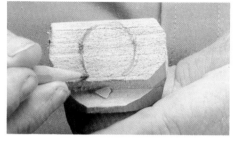

then draw the round shape you desire.

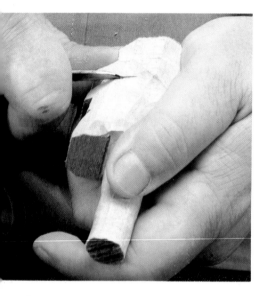

Cut a stop around the bill and the rest of the cap.

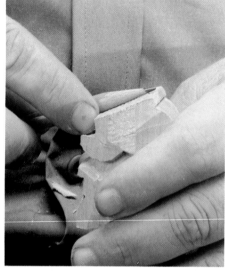

The top of the kepi is round. To get the shape use your finger and a pencil to measure the distance from the front to the back of the flat surface.

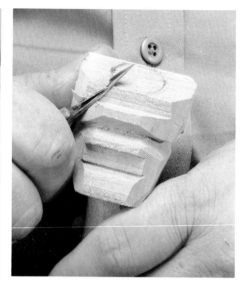

Trim the sides of the kepi, tapering from the bottom of the cap to the top.

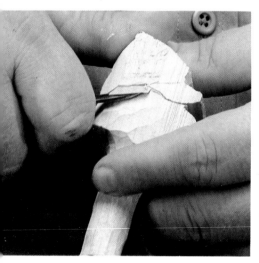

Trim back to the stop from the head.

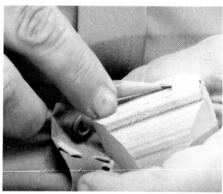

Transfer that measurement from side to side...

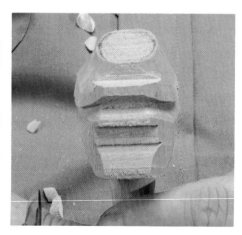

The kepi should look something like this when you are finished.

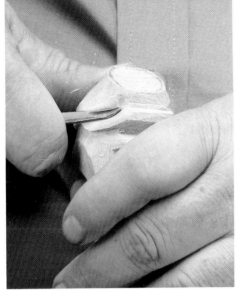

Straighten the bill of the kepi, bringing it back to the crown.

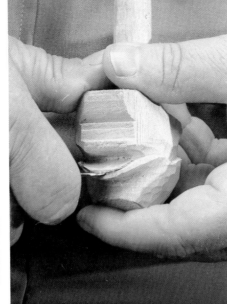

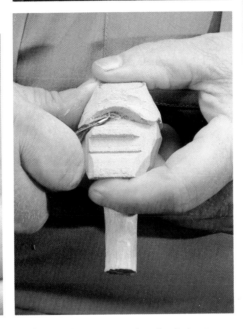

Cut along the line with a knife. Cut in one direction letting the wood break off naturally. If you use the method of making a stop cut and carving back to it, you are likely to cut off the bill of the kepi in this situation. Also, while you can use a gouge, the knife is a much safer tool in this spot.

The bill so far.

Clean the area under the brim to the forehead.

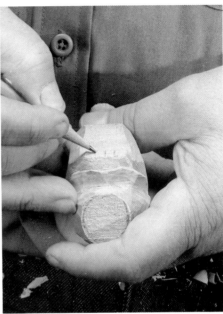

Mark the center of the nose and the sides, making it good and wide. You can narrow it later, but if you make it too thin now, you will have a hard time adding to it.

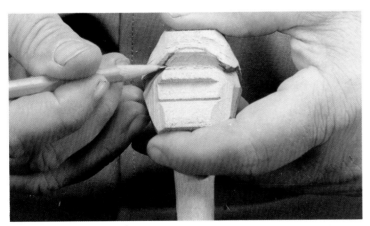

Next we come under the bill. Make sure your knife is very sharp before you start doing fine work like this. This will make the cutting easier and reduce the chance of breakage. Mark the underside of the bill with a pencil.

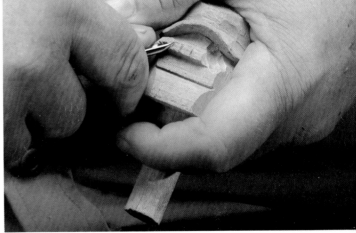

Use a small half-round gouge along the side of the nostril and nose to form the shape of the nose...

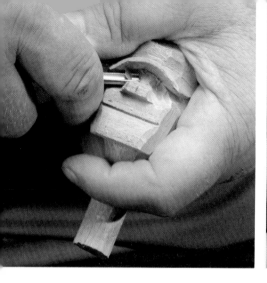

and in from the side of the face to begin to form the eye socket.

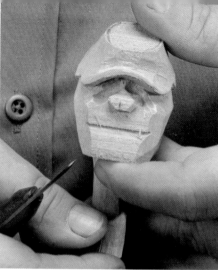

This should take you to this point.

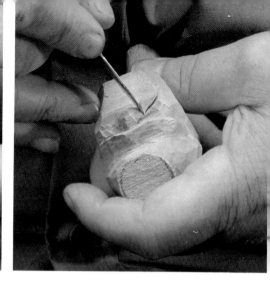

Make a small stop at the corner of the nose to protect it from breaking off. This will form a triangle with the cheek and moustache lines.

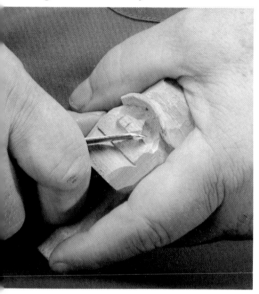

To form the nostril, cut straight into the underside of the nose at a forty-five degree angle...

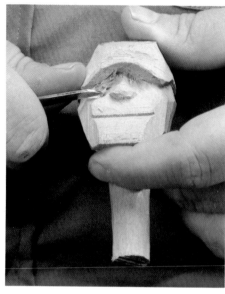

Finish the nose by rounding it off.

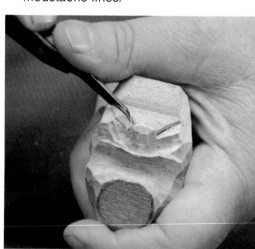

Come back to these stops from the moustache. Don't try to pry off too much. Instead, repeat the same cuts until you get deep enough.

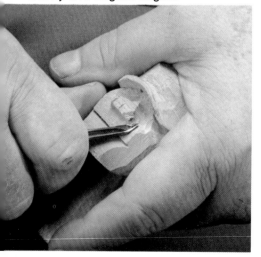

and cut back over to it. Repeat on the other nostril.

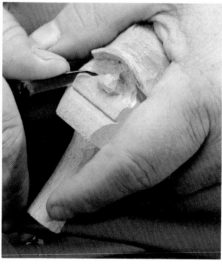

Cut a straight stop that will define the cheek and the moustache lines.

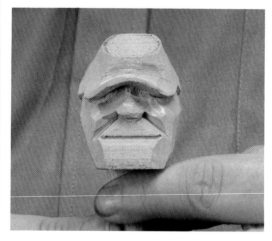

The face to this point.

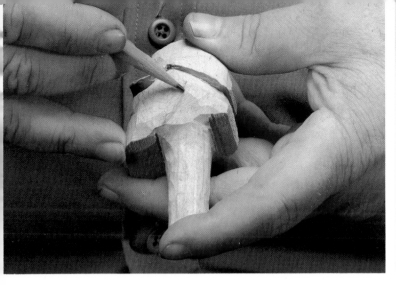

Draw in the bottom beard line so it comes just in front of the bottom earlobe. Most of the ear will be covered with hair.

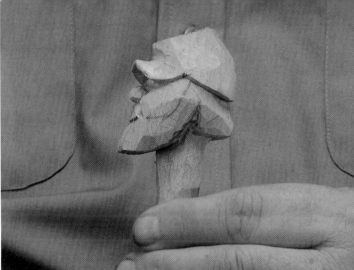

Clean up the lines with a knife.

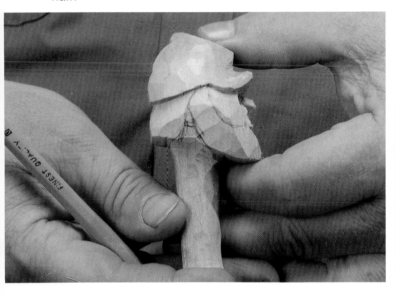

Continue to draw in the top beard line, the ear lobe and the hair line.

With a gouge, go up the side of the face along the top beard and sideburn line.

Again use a small half-round gouge to come under the earlobes and get the separation between the hair and the beard.

Trim the face back to this gouged area, blending them together.

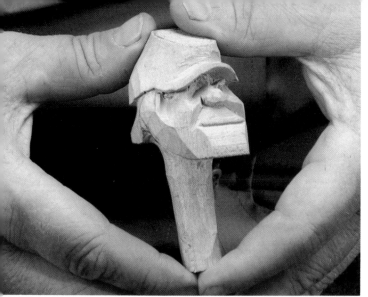

Progress so far.

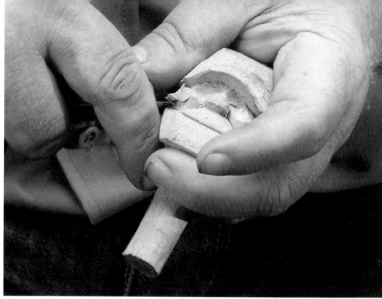

Come back into the stop from the beard line, with the cup side of the gouge up.

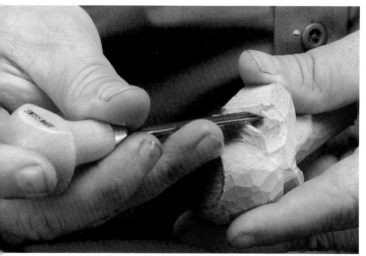

A flatter gouge is used to shape the cheek. To decide what size, hold the gouge with the cup side against the cheek, and visualize the shape the cheek should be. If the gouge seems right, use it. If not, try another.

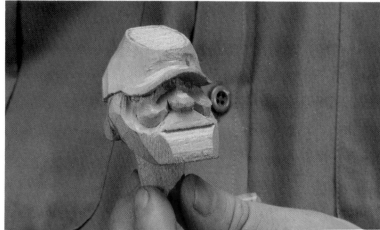

This method creates rounded cheeks and a jovial look.

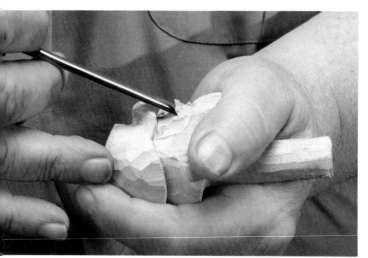

With the cup side of the gouge against the cheek, cut a stop down to the beard line.

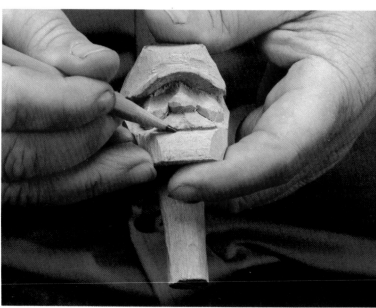

Draw in the moustache. I've marked it to leave one tooth, giving the character an older look.

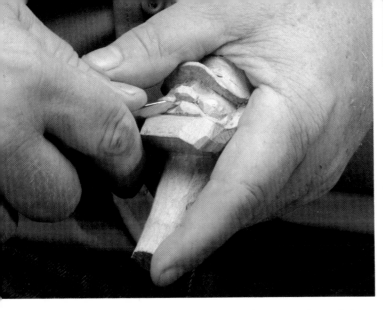

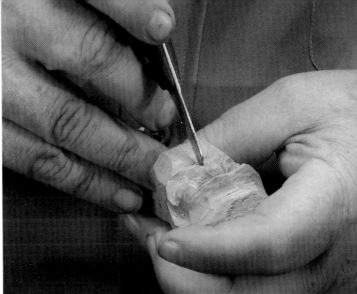

Make two straight-in cuts on the bottom edge of the moustache. Don't go too deep or you'll cut off the tooth. Do one side...

To form the tooth and the opening of the mouth, make a straight cut down the middle...

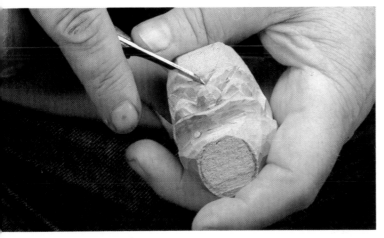

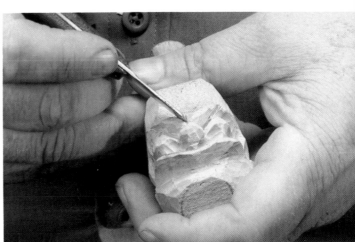

then the other.

a straight cut along the lower edge of the moustache...

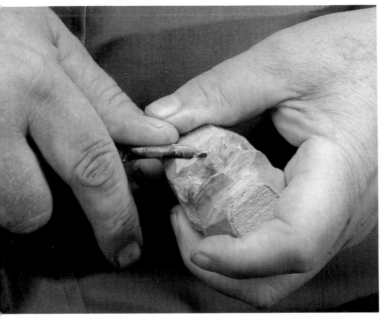

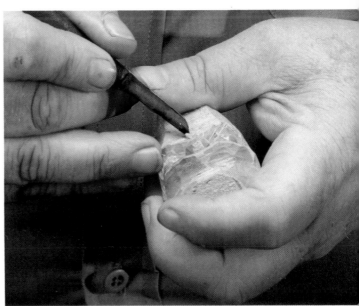

Cut back to the stops shallowly, leaving the tooth.

and a cut along the lip which should pop out the triangle of the mouth where there is no tooth.

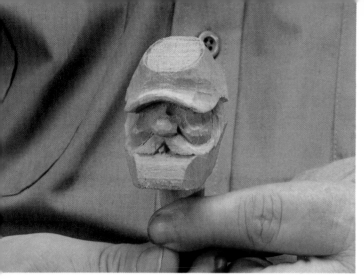

This is the resulting mouth.

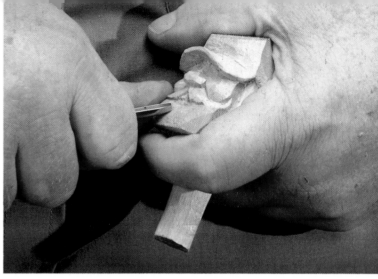

Trim the beard back to the lower lip.

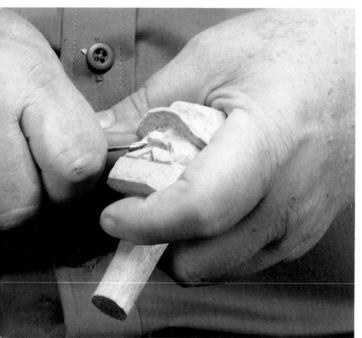

Go around the face, smoothing and cleaning up the rough spots.

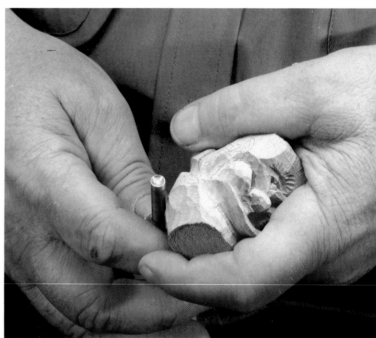

Choose the eye punch that is the correct size for the chin strap button by holding it up next to the kepi.

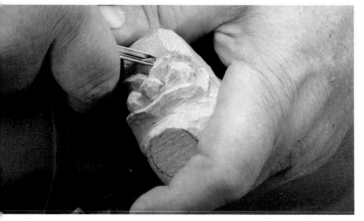

Use a small half-round or U-gouge to form the bottom lip. Simply go across the chin beneath the bottom edge of the lip.

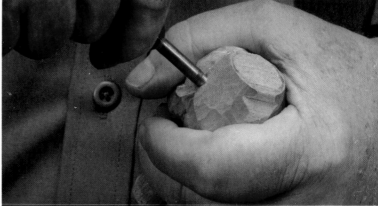

Position the punch where you want the button, apply a little pressure and twist the punch to form the shape. Too much pressure may cause you to slip.

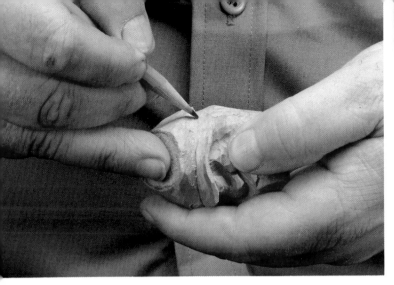

Mark the line of the chin strap just above the bill of the kepi.

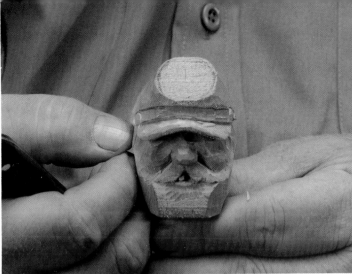

To create the slouch of the front of the cap, cut a stop into the cap above the strap. Cut back to it from the strap so the top of the kepi folds over the strap.

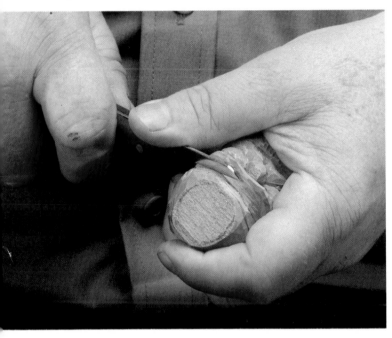

Draw the other line of the strap and cut a stop along the bottom line.

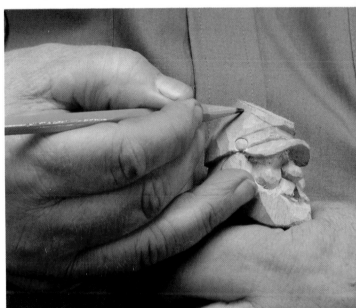

Mark the fold as it continues around the sides of the kepi.

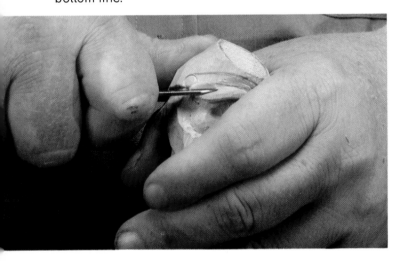

Cut back to the stop from the bill.

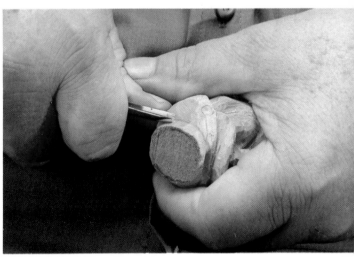

Follow the line with a narrow gouge creating a groove.

21

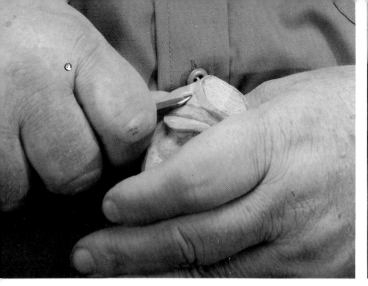 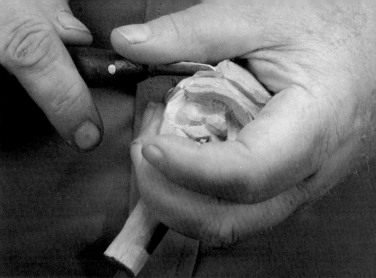

Trim back to the groove with a knife so that they blend together gradually.

and cut back down to it.

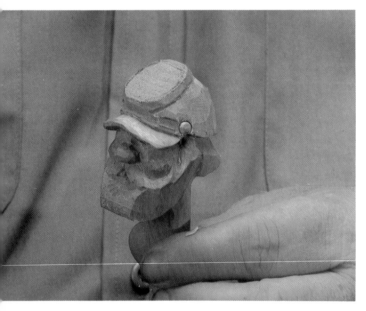 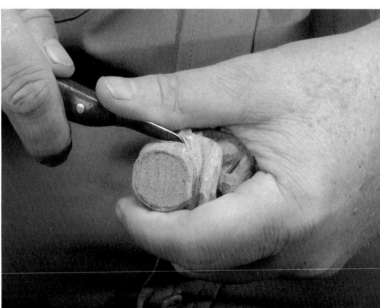

The kepi so far.

On the sides of the cap create folds by cutting out long wedges. First cut one way...

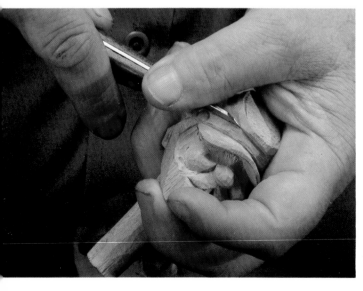 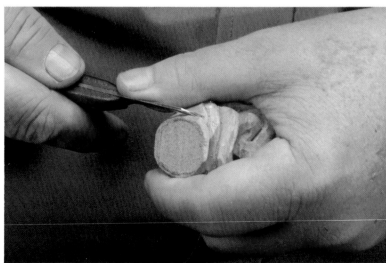

Go back and cut a stop along the top of the chin strap.

then the other.

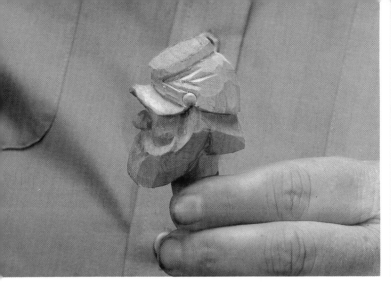

A pattern like this should give the effect we're after.

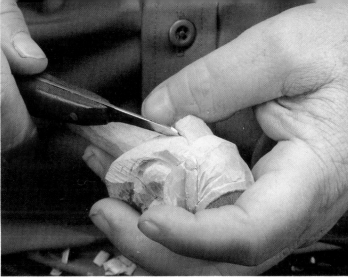

To create the earlobe make a stop along the beard line...

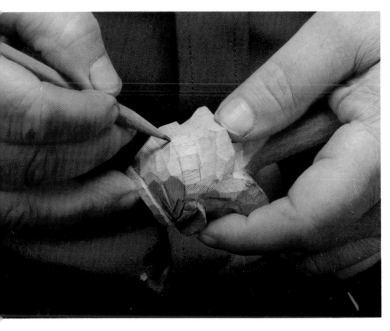

A strip of ribbon was usually used around the back of the kepi. This was in different colors to indicate the unit of the soldier. Red was for artillery, yellow for cavalry, but the infantry had no ribbon. Draw the line.

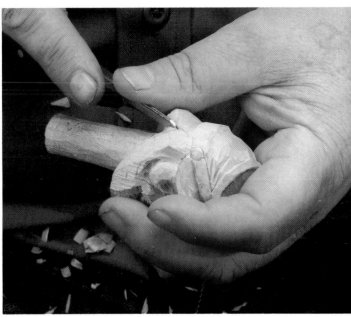

and along the hairline.

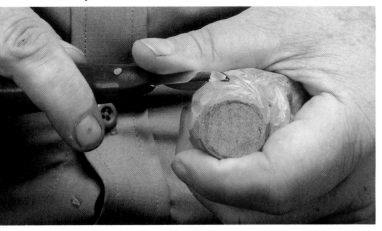

Carve up from the line into the cap with a little snitch, creating an indentation to denote the ribbon.

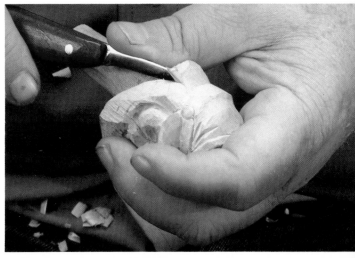

With the point of the knife, come into the V formed by these lines and lift out the triangle, leaving the earlobe at a deeper level.

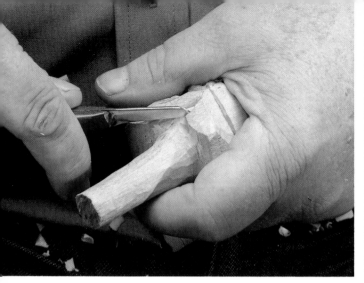

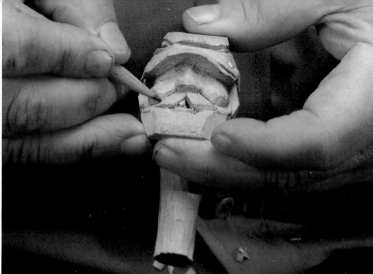

After that, you repeat the steps below the earlobe to thin it and give it detail. First cut along the bottom of the earlobe...

Mark the ends of the moustache to define its shape.

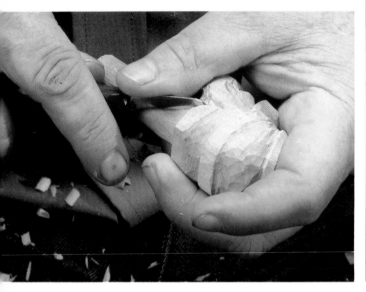

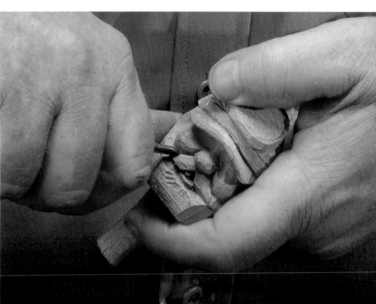

then along the hairline.

Make a stop along the top edge of the moustache...

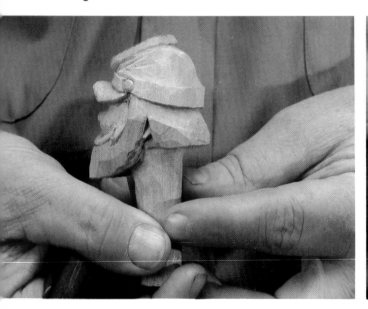

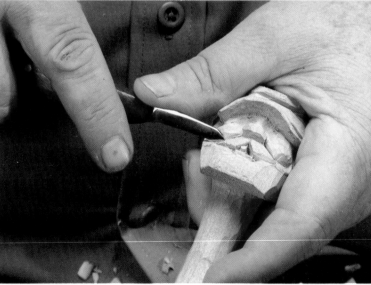

Lift out the triangle for this result.

and another down the line of the cheek...

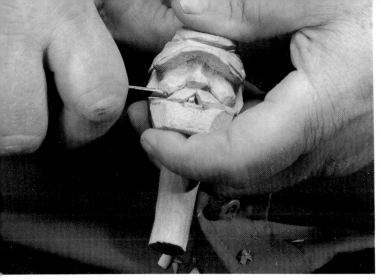

and cut back to them from the beard line.

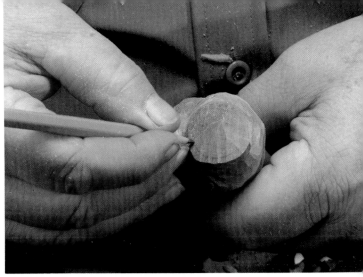

Clean the saw marks on the top of the kepi then mark the rim.

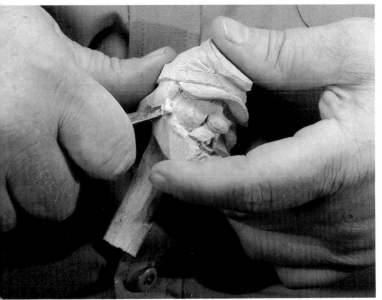

Go back and round everything up.

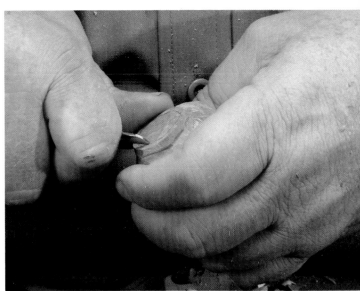

Cut a stop all around the rim.

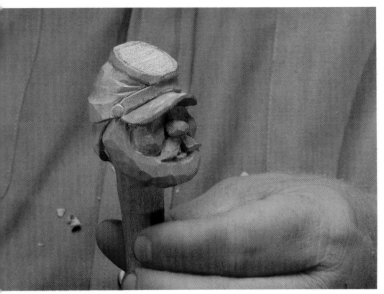

The head so far.

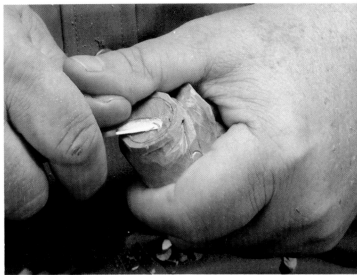

Cut back to the top from the center, keeping the knife as flat as possible.

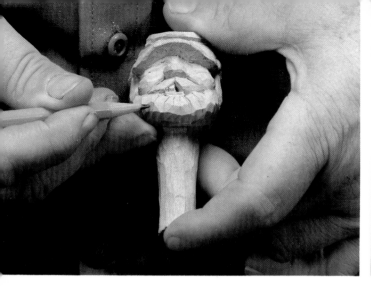

Draw in the lines of the beard, beginning with the strongest lines.

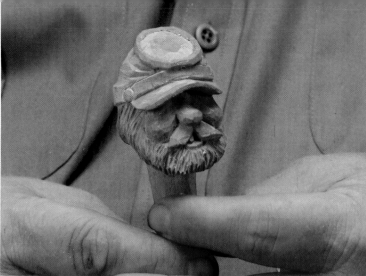

The beard with the hair carved.

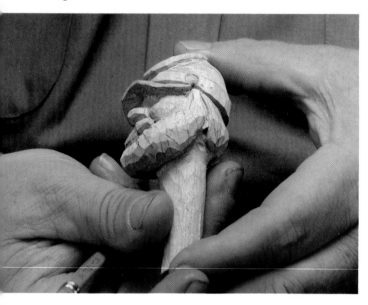

Make all the hair flow away from the face.

Before adding the hair to the moustache, create the nostrils using a small half-round gouge. Go into the nostril with the cup toward the moustache.

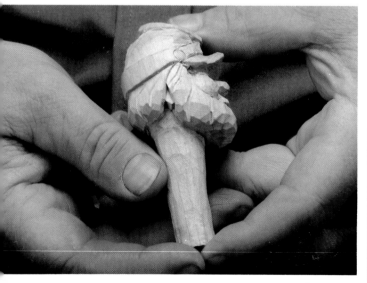

Using a small veiner carve the major lines first. Then go back and fill in the other hair lines.

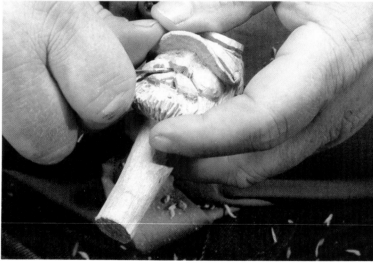

Then cut back to it with a knife.

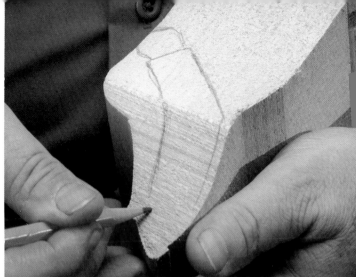

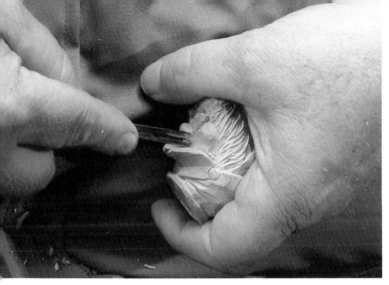

Use the same gouge to create the outside top of the nostril, giving it its flare.

Draw the hand and arm that will hold the gun.

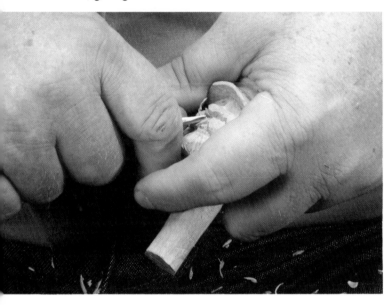

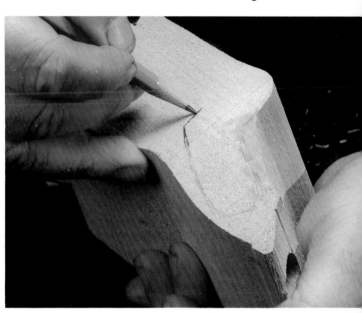

Use the veiner to create the hairlines in the moustache. Keep the line running away from the center. Do the same with the hair on the sides and back of the head.

Draw the arm that will hold the flag...

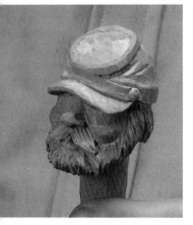

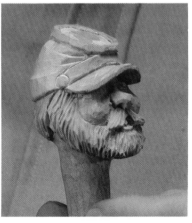

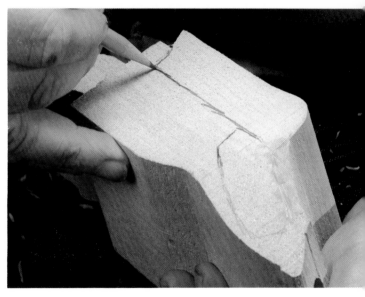

The head so far. We'll put it aside for now and work on his body. When we near the end we'll come back to the eyes. After we set the attitude of the body we can be consistent with the eyes.

and draw the flag.

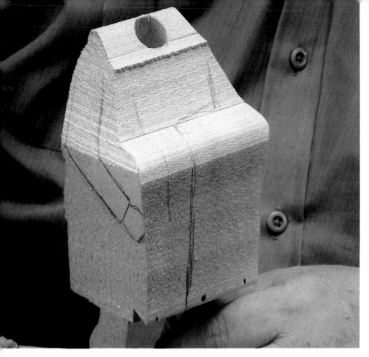

Continue the lines on the front. These are working lines and may change as we get further.

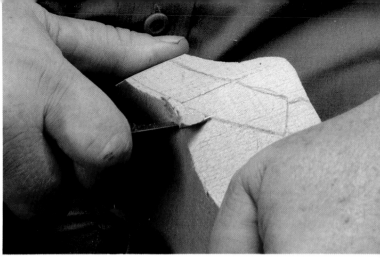

Bring out the arm by cutting a stop on the line of the arm and carving back to it from the body.

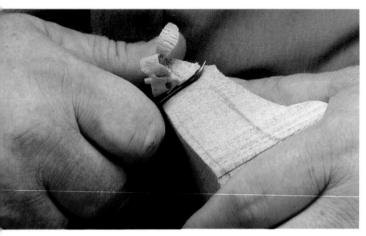

Trim the shoulders so they drop down from the neck. This is always the natural look, and particularly with this character where we want him to show some age.

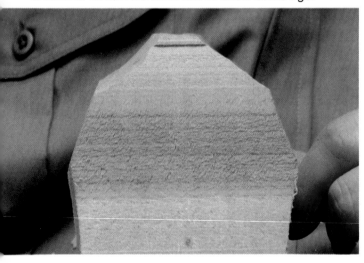

This shows the line of the shoulder.

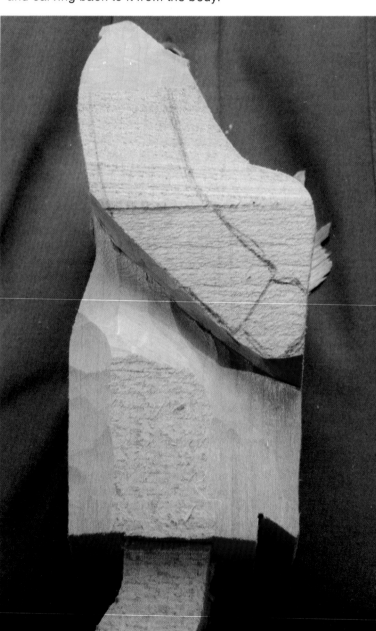

Continue down the bottom of the arm and round the corners of the bottom of the coat.

28

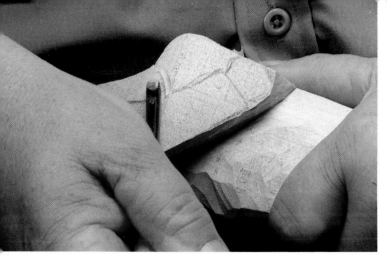

Use the gouge to remove the excess wood above and in front of the arm. This seems to work better than a knife on inside curves.

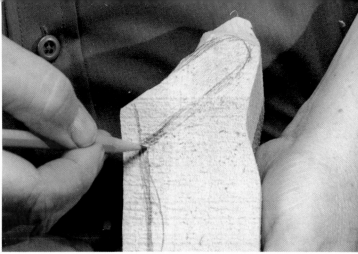

Move to the flag holding arm. After some initial rounding it is important to define where the elbow will be. You may have to erase some earlier lines to make it look correct.

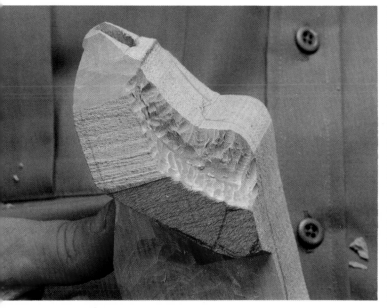

The gouged front of the arm.

Continue to round and bring out the arm using the knife or gouge, depending on which works better.

Go back and clean the area with a knife.

Using the gouge mark behind the arm as a stop, round the back of the coat.

Smooth the gouge marks and continue to shape and refine the upper body.

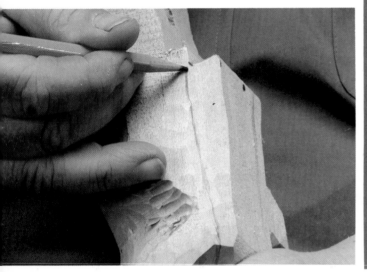

Redraw the lines which were cut away.

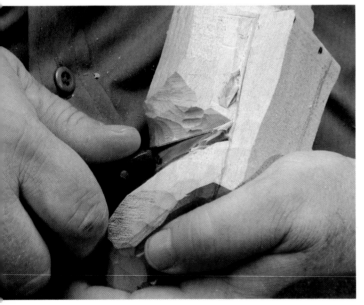

Using the stop and cut method with the knife, remove the excess material between the flag and the body.

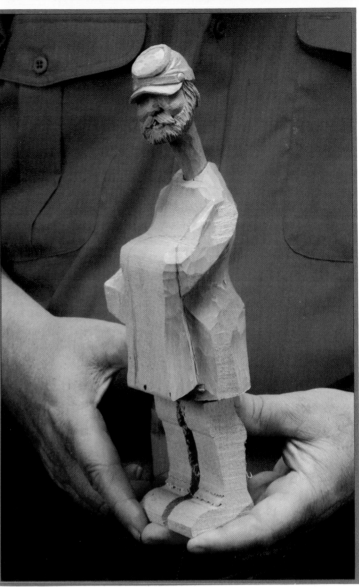

The shape of the flag is roughed out and it is now time to shorten the neck to get it in the proper proportion to the body.

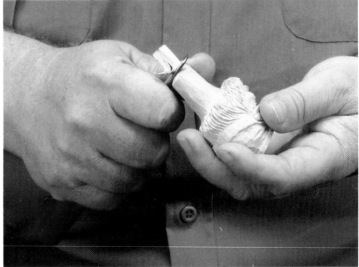

Simply whittle off the end of the neck to get to the length you like.

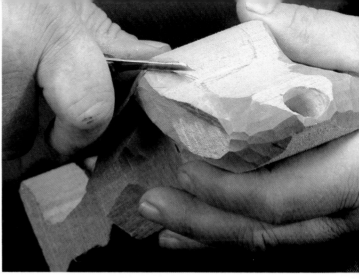

After the end is taken off, taper it down to fit in the neck hole. As before, when it is tapered, place the neck in the hole and turn it back and forth while applying a little pressure. This will produce shiny spots on the neck that need to be trimmed further.

Cut a stop along the edge of the flag.

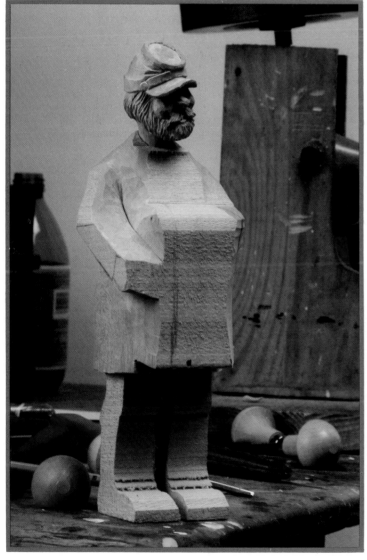

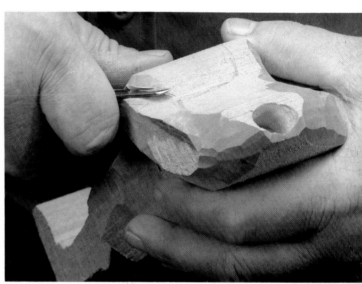

Cut back to the stop from the arm. Continue the process all the way around the flag.

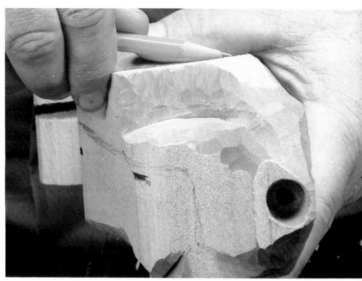

With the neck shortened, the head seems to be right for the body.

To make sure the arms are about the same size, use your pencil to measure the one you have already roughed out...

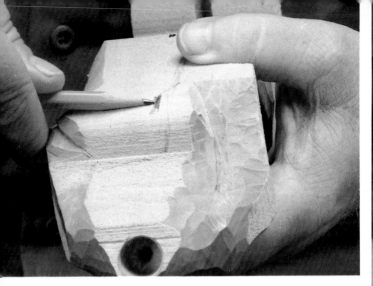

and transfer it to the arm carrying the flag.

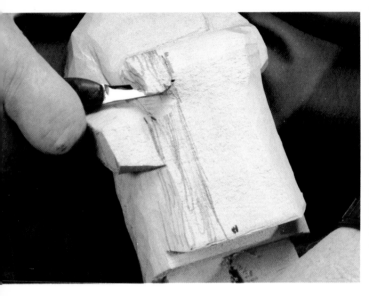

Continue the mark down the flag, blackening the area to be removed. Remove it using a knife and a gouge. Make sure your tools are sharp.

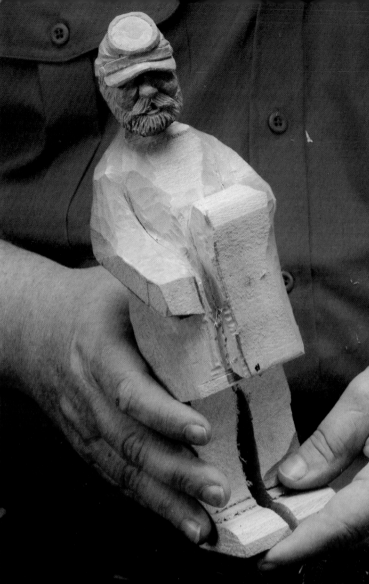

The roughed-out flag.

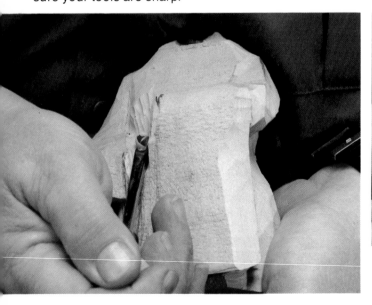

The gouge works well in hard to reach places.

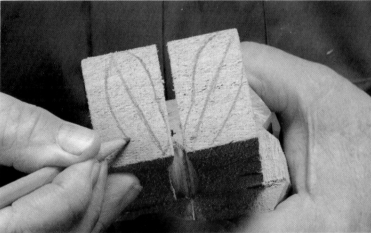

I've decided to have the head turned toward the flag side, so the left foot will turn out slightly more than the right. Mark the center line of the foot on the sole, and draw the shape of the shoe.

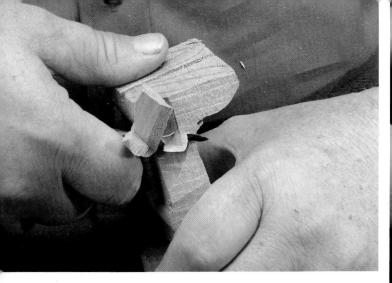

Pop off the excess wood around the foot.

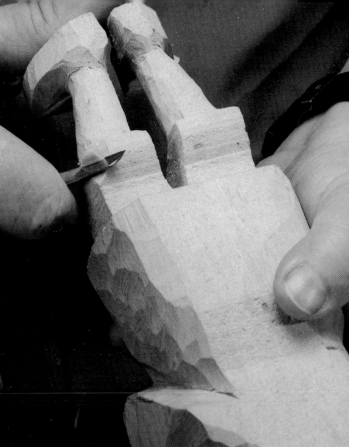

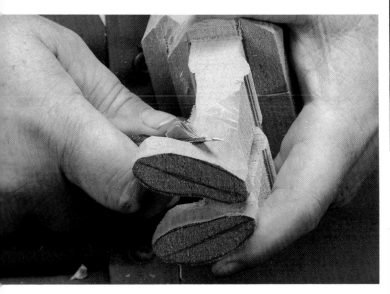

When the sole is shaped, begin to round off the top of the boot. Don't carve too much in one place or the legs will look flat. Move around and around, beginning with the ankle area...

When the boot is shaped, trim the pants. Not only are they too blousey for the uniform, but they also get in the way of the carving.

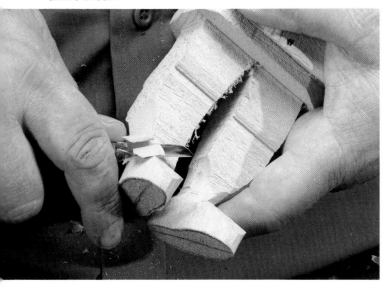

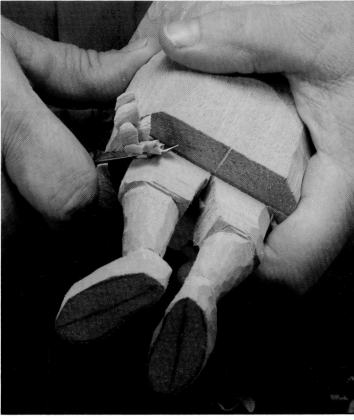

and move up the leg.

Round the leg and refine the pants.

33

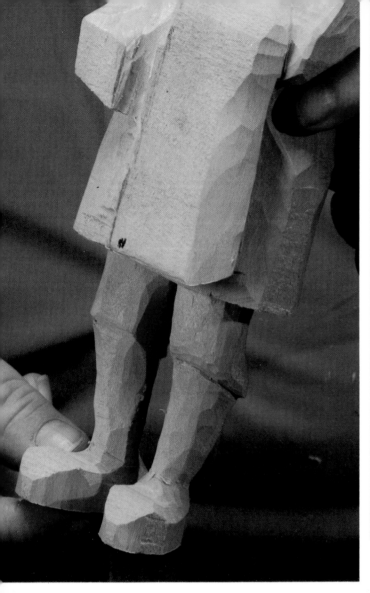

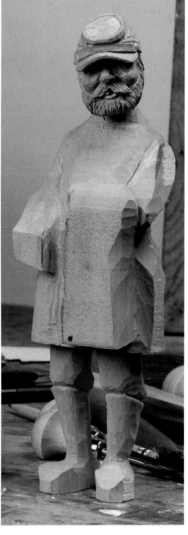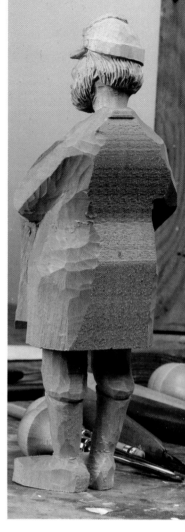

The lower body so far.

Our soldier is beginning to shape up.

From the back you can see that he is quite broad in the middle and across the hip. A diet is in order.

Cut a stop around the top of the boot and trim back to it from the pants. The Civil War boot was usually higher in the front than the back.

Trim around the coat, rounding as you go.

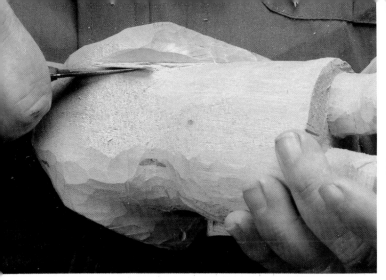

Start to shape and bring out the right arm. Cut a large V-groove under the back side of the arm, between it and the body. If it will work it would be nice to go through and bring the arm away from the body. Unfortunately, in this case the wood looks a little narrow to allow this. It is always good to start with a wide enough piece of wood.

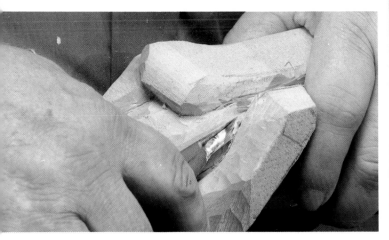

Cut a similar V-groove between the body and the front side of the arm.

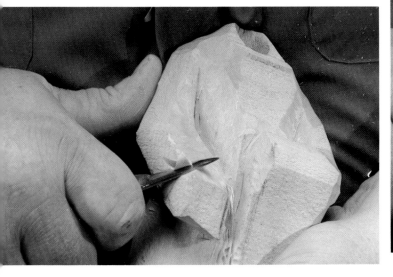

After creating space between the arm and body, begin to shape the arm. Leave the hand blocky for now.

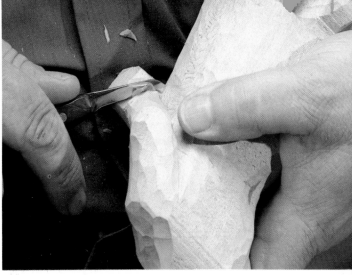

Create the cuff by cutting a stop around the end of the sleeve and cutting back to it from the hand.

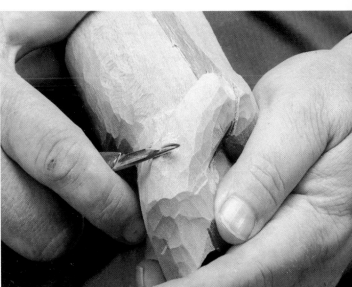

Now move to the flag arm, and round and shape it.

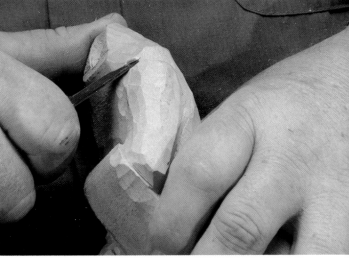

Visually the upper flag arm looks too long, so I'll drop the shoulder down to where I've marked it and trim back toward the neck.

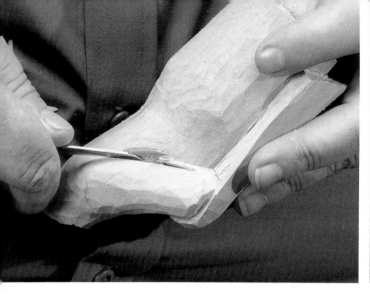

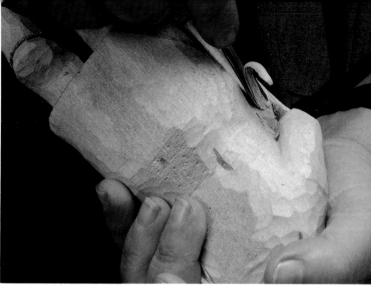

Next, separate the arm from the body with a deep V-groove.

After the tight spot is cleared, remove the easier to reach spots with a half round chisel. I begin with a large one...

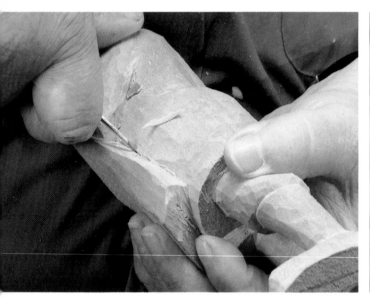

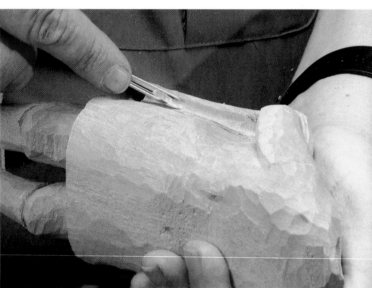

Separate the flag from the body using the same technique.

and move to progressively smaller U-shaped chisels as I go deeper.

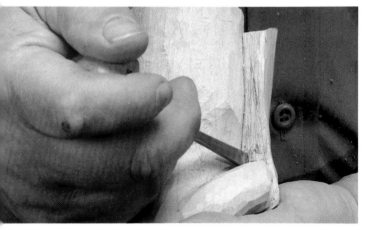

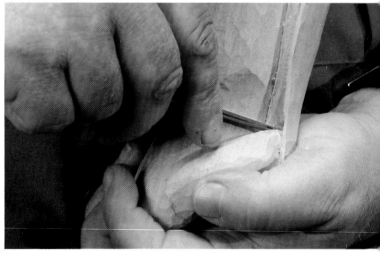

Mark the area to be removed between the folded over sides of the flag. To get into tight spaces I use a flat chisel, with an angled end. This does the job nicely. Simply push and rock the chisel to cut into the wood you wish to remove.

To clean out these small spaces I like a flatter gouge, no more than 1/8" wide.

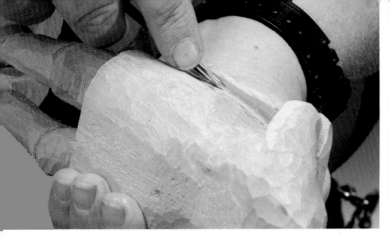

Finally use a veiner to give it the depth and sharpness you desire. I use my hands as a vise when using gouge tools, being careful to place them in such a way that if I slip I won't stab myself. Sometimes mistakes happen, however, and it's painful. The safest way to gouge is to use a vise or other hold-down device.

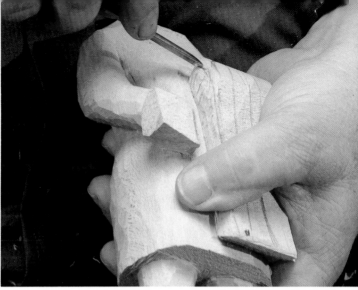

Use a flatter gouge with the cup side down to cut a stop between the fingers and the flag.

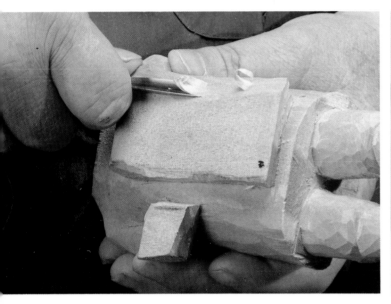

Use a flatter gouge to create the smooth folds of the hanging flag. This is somewhat tricky, and it might help to hang a piece of cloth and see what it actually looks like.

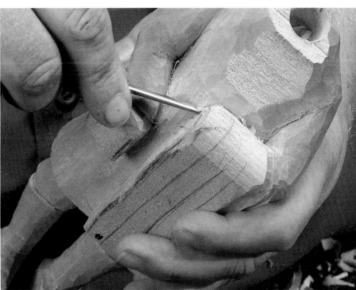

Continue with the gouge cup-side down to cut from the hand to the stop.

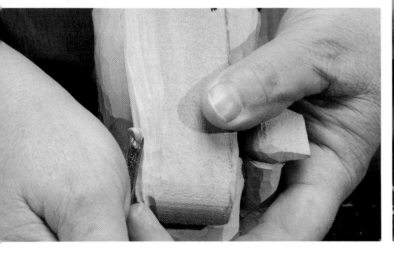

A smaller gouge can be used for small folds, a larger for large folds.

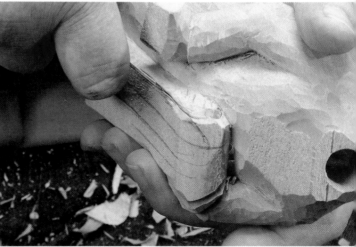

With a knife bring a stop part way down the edge of the flag.

37

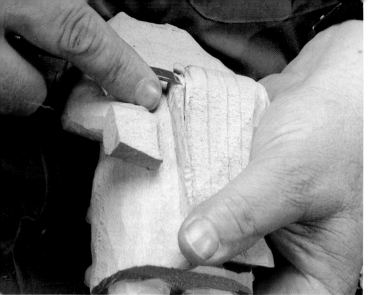

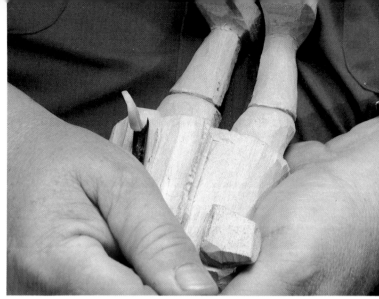

Come back to the stop with the angled flat chisel. Use the same tool to bring out the hand. Create the fold-over like you did on the other side using progressively smaller gouges and a veiner.

For tighter folds use a narrower gouge.

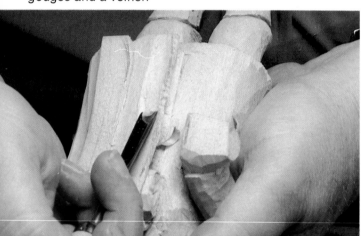

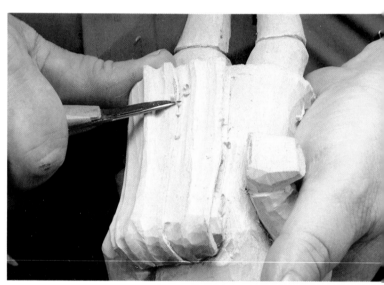

Run the folds down the front of the flag with the flatter gouge. This will give the broad sweep you want.

Go back and clean things up with a knife, erasing all the unwanted lines.

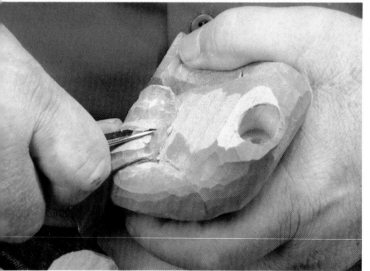

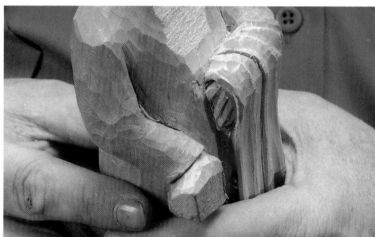

At the top it is easier to do the folds with a knife.

Back to the flag hand. We want the hand to just show, although you could have it showing completely. Begin by rounding and shaping it with a knife. Then draw in the fingers.

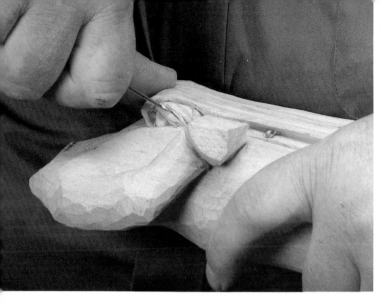

Make V-cuts along the finger lines with a knife to define them.

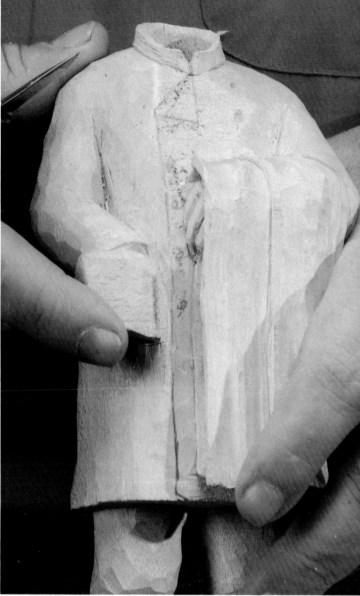

Draw the details of the coat.

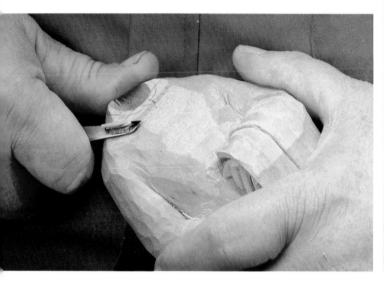

Draw in the details of the collar and trim up to it from the torso. This is a stand-up collar, which is not hard to carve, but is somewhat fragile. You need to leave it somewhat thick, but may be able to flare it out from the inside. This preserves some of its strength while not making it look like a turtleneck.

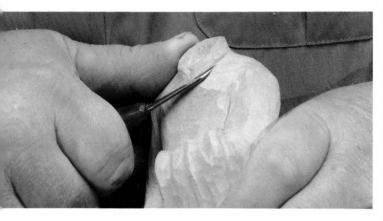

Use a knife to cut a V-line around the base of the collar to make it distinct from the coat.

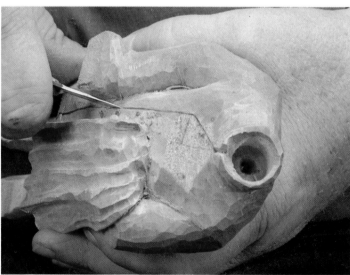

Cut a stop down the opening of the coat.

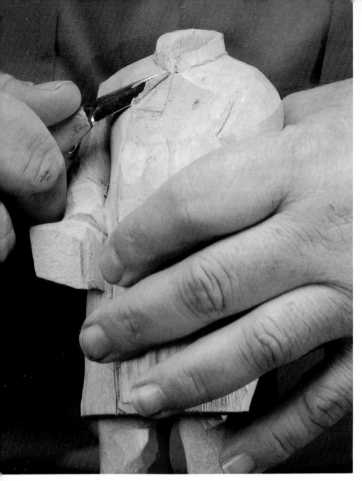

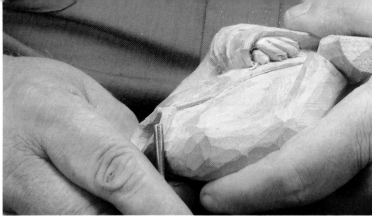

Cut stops around the lapel fold-back, and trim back to them from the coat front. Choose the correct size of eye punch to form the button by holding it next to the piece and visualizing it. These eye punches may be available from major woodcarving suppliers, but if you can't find them a nailset will do.

Trim back to it.

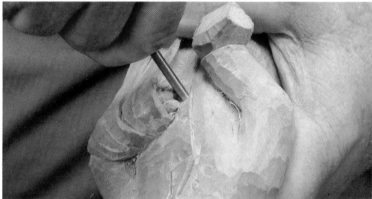

To form a button, gently push and turn the punch in the appropriate place.

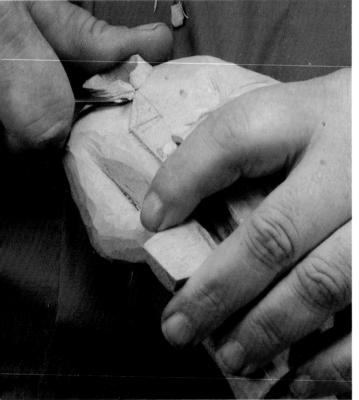

Where the lapel folds back, make the cut a little deeper so the fold will have a nice curve.

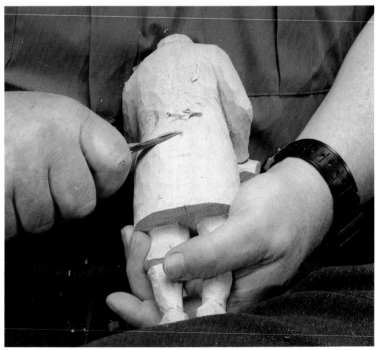

Go over the whole piece, refining, looking for problems, and removing rough places.

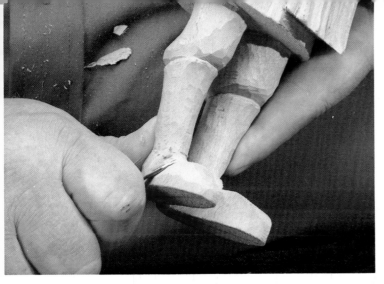

Round and shape the boots.

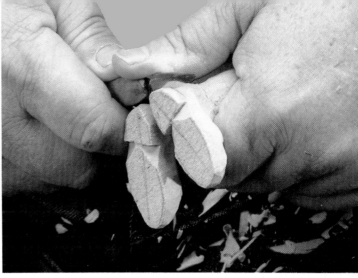

Cut stops around the soles with a knife, and trim back to them from the shoe. I use a knife instead of a v-tool, because the v-tool tends to chip when going against the grain.

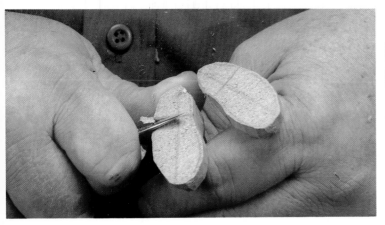

Mark the heels on the soles of the boots, and cut a nitch on their outer and inner corners. This is done by making a straight cut on the heel line and cutting back to it at an angle along the edge of the sole. I don't cut all the way across so I can keep a larger gluing surface.

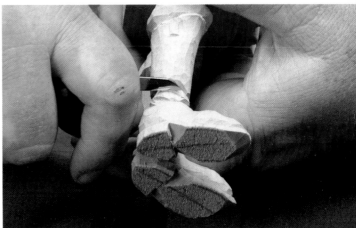

I add wrinkles to the ankles of the boots by making V-cuts with the knife.

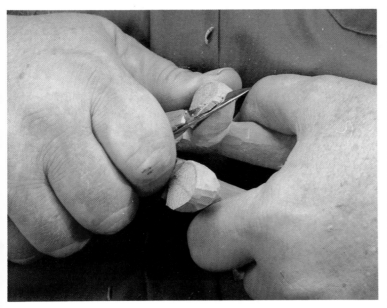

I think the soles need to come up at the toes, so I angle them up.

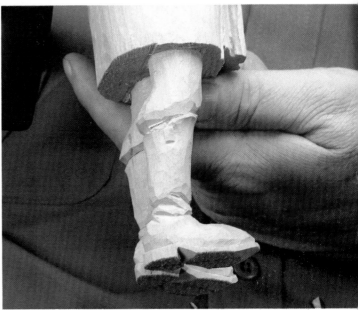

This is the effect.

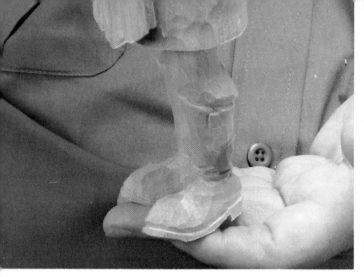

With the addition of a pull tab on the side, the boots are complete.

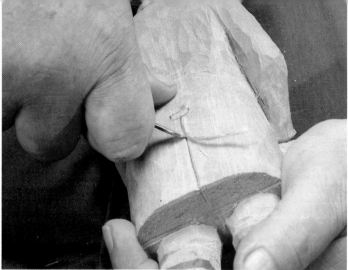

Make a V-cut down the vent line with either a knife or a v-tool.

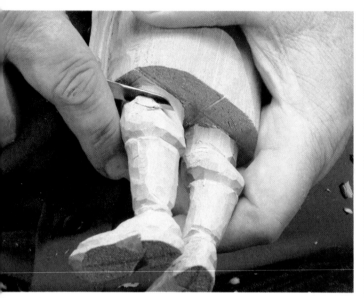

Add wrinkles to the back of the knees in the same way that you did at the ankles.

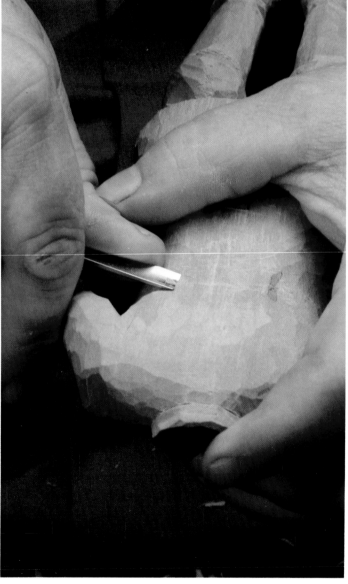

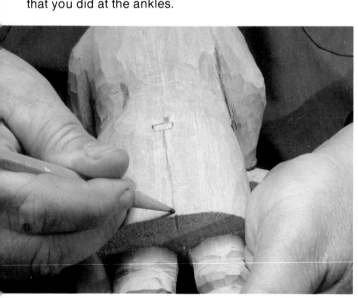

Draw the vent up the back of the coat to the waist.

In the small of the back and other areas where end grain is exposed, a nice sharp flatter gouge coming across the grain will clean up the rough spots nicely.

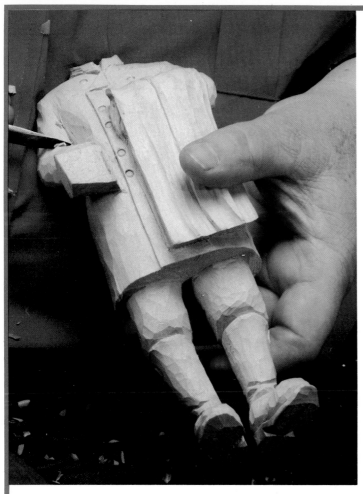

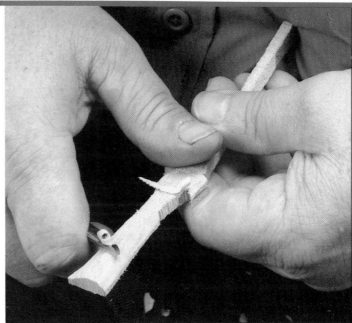

Whittle the gun down until it looks right. You are more concerned with form than details when working with the gun, so that you achieve something that is a good representation of a gun. The perfectionist can add details when the form is right.

Go back over the piece cleaning it up and adding details like the folds at the elbow of the coat, the small of the back, and other natural spots for more realism. I spend a lot of time looking for places that don't look quite right. After I figure out what's wrong I try to fix it. Be particularly aware of saw marks, removing them when you find them.

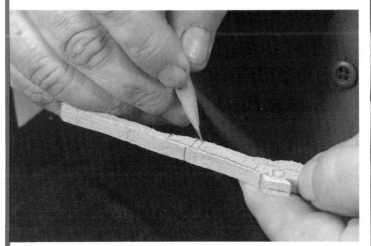

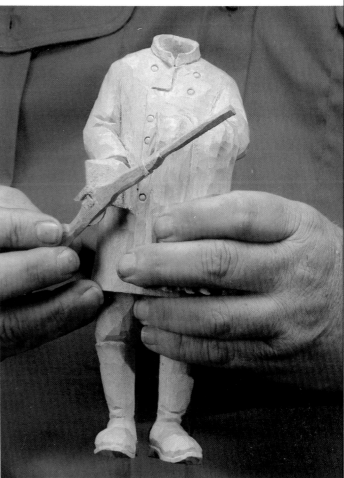

The last part of the body is the hand that will hold the gun. But first we need to do the gun. Sometimes it is simply difficult to do the details of the gun in wood. When working with this small object it is impossible to carve the trigger and hammer mechanisms, or the sight. Even if you do carve them, they are liable to break off anyway. Mark the blank, using the pattern or a good illustration as a guide.

When the gun is roughly carved, hold it up to the body to see which way it should be held.

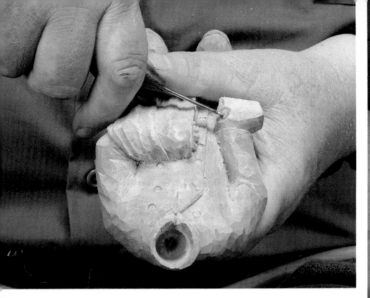

In the hand draw the hole for the gun, then make a little notch for the drill bit to catch hold.

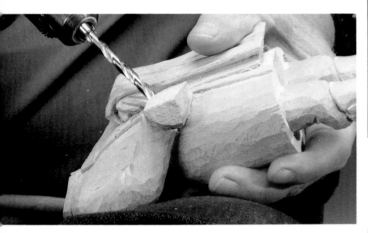

There is some danger of breakage here, but it is a risk that must be taken. Use the slowest drill you can. The best thing would be to put the piece in a vise and use a hand drill. A battery-powered drill is also slow. The third alternative is a flexible shaft, variable speed drill. Finally you can use an electric hand drill. Put the bit in the notch, hold the drill at the angle you wish the gun to have, say a prayer, and drill with short bursts.

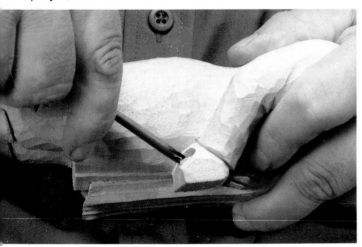

Use a gouge to elongate the hole, making it oval to accommodate the rifle.

Remove the trigger and hammer assembly, which will be covered over by the hand. Making the gun fit in the hand will involve more sanding and carving of the gun and the hand.

This is the time for creating uniform sizes and getting things small enough to fit into the hand. Sand the rifle using a medium sandpaper. Be sure to clean the piece thoroughly after sanding, or, when you return to carving, little pieces of sand in the crevices will play havoc with your tools. Go back with the knife and restore the details that may have been lost in the sanding.

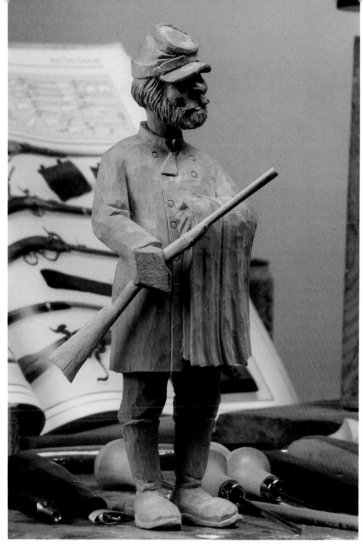

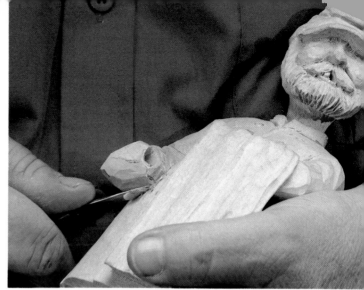

With the gun removed, carve the shape of the hand. I'm going to let it rest against the body for strength.

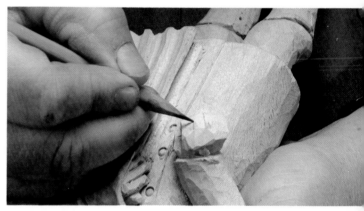

With the gun fitted the only details left to finish are the right hand, the seams and stitches on the clothing, and the eyes.

Draw the lines between the fingers, beginning with the line between the ring finger and the middle finger and working out.

Rough out the roundness of the hand with the rifle in place. This gives you an overall perspective. Then mark the area of the fingers to be removed.

Run a small veiner along the lines between the fingers to create the separation you need.

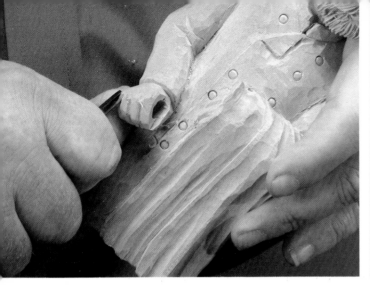

Use a bigger gouge to create the spaces between the knuckles.

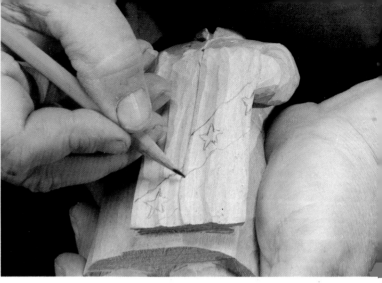

Draw in the details of the flag. This flag, while usually thought of as the Confederate flag, was actually that of General Beauregard. There were several varieties of flags in the Confederacy, many of which incorporated the Stars and Bars.

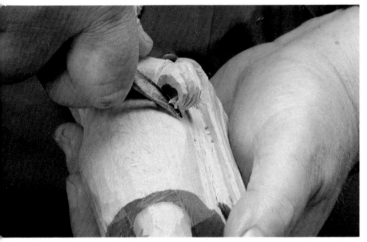

Use a knife to finish up the hand. Usually you end up with one finger too big. If you're lucky its the little finger and it can be easily trimmed. The hand looks a little club-like, but we need to keep some of that for strength.

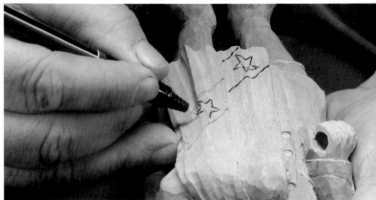

Go over the lines of the flag with a marking pen. It is important to be sure that the ink does not run when painted, so test it first with the paint you will be using. I have found a Flair™ pen or a Pilot Precise V5 Rolling Ball™ pen to work well with my turpentine-based paints.

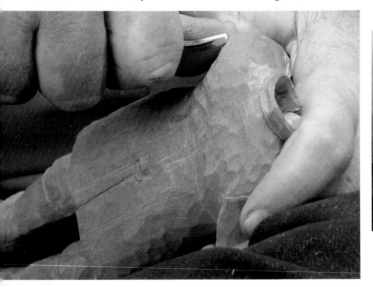

Seam lines on the sleeves, shoulders, pant sides, and down the back and around the waist of the jacket are carved with a v-tool.

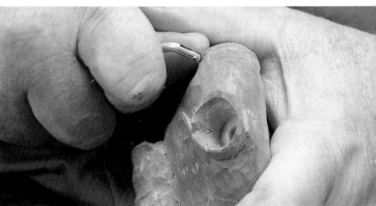

With a tracing wheel the stitches are placed alongside the seam lines and where the braids and patches once were. When the Civil War was over, a soldier kept his uniform, but often tore off the decorations and embellishments. Remember to include stitches on the lines of the flag.

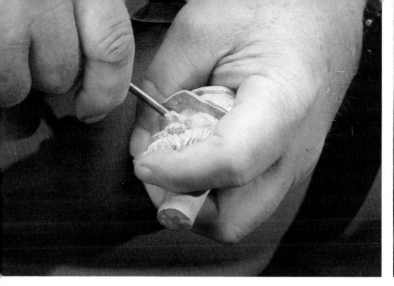

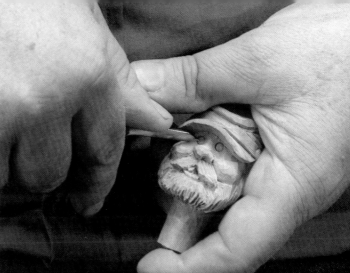

Back to the eyes. If you are right handed do the figure's right eye first. This will give you perspective for the other. Take the appropriate size eye punch and push and turn.

Cut the top line of the eye opening straight into the corner.

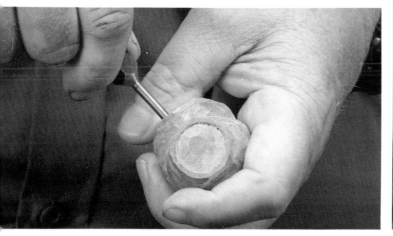

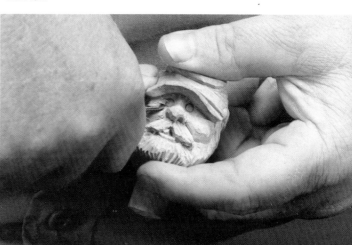

Do the same with the other eye.

Do the same with the bottom line. Repeat these triangles at each corner of both eyes.

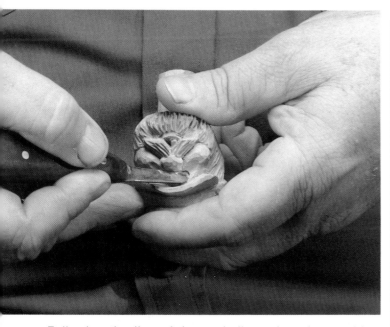

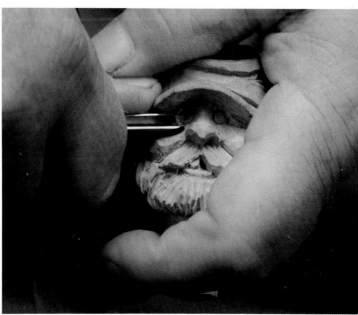

Following the line of the eyeball, cut into the outside corner of the eye. This is the first side of the triangle that will make up that corner of the eye opening.

Use a small half-round gouge to put bags under the eyes, giving them character.

47

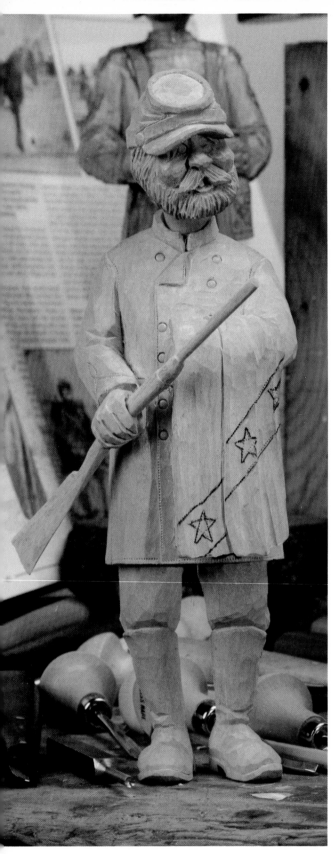

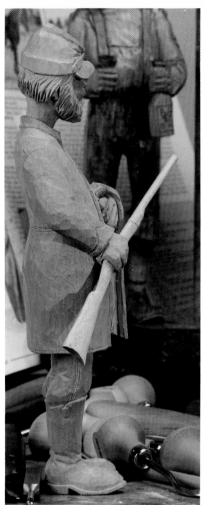

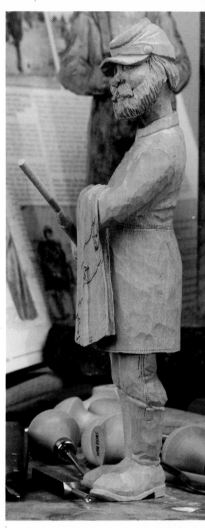

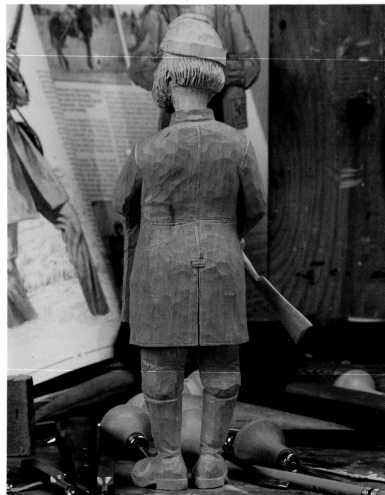

Ready for painting.

Painting the Soldier

The only all gray uniforms that I have been able to get pictures of were Union, especially from some of the New York regiments. Some of the Confederate uniforms were almost all blue. That led to a lot of friendly fire. If I remember my West Virginia history, Stonewall Jackson, who was born and raised there, was killed by friendly fire. He was returning in the fog and was mistaken and shot as an enemy by his own men.

For wood carving I use Winsor and Newton Alkyd tube paints. These are thinned with pure turpentine to a consistency that works with the carving. I mix my paints in glass juice bottles, putting in a bit of paint and adding turpentine. I don't use exact measurements. Instead I use trial and error, adding a bit of paint or a bit of turpentine until I get the thickness I want.

What I look for is a watery mixture, almost like a wash. In this way the turpentine will carry the pigment into the wood, giving the stained look I like. It has always been my theory that if you are going to cover the wood, why use wood in the first place. It should be noted that with white, the concentration of pigment should be a little stronger.

The juice bottles are handy for holding your paints. They are reclosable, easy to shake, and have the added advantage of leaving a concentrated amount of color on the inside of the lid and the sides of the bottle which can be used when more intense color is needed.

Test paint on a wood chip of the wood you are using. Wood differs even when its the same kind.

Begin with the head. For skin tones I use raw sienna mixed with a dab of tube flesh. Apply it to all the skin areas of the face and neck.

A touch of cadmium light red blended into the cheeks, nose and lips will give the face more life. Continue with some red around to the back of the neck. If you get too much red, go back over it with more of the flesh mixture.

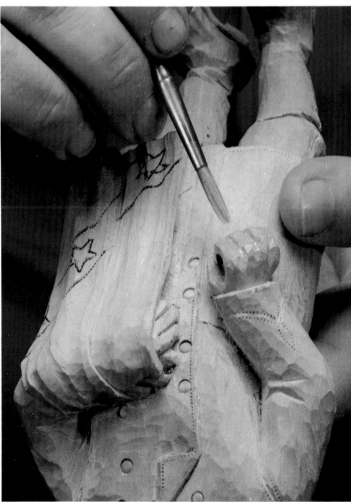

Continue on the hands with the flesh mixture and red accent.

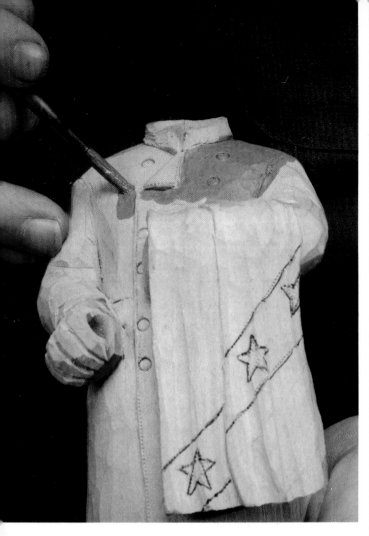

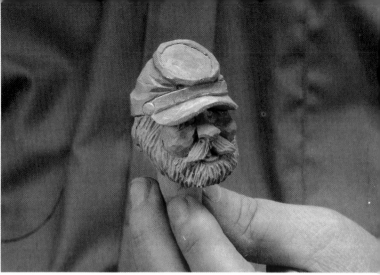

The head so far.

Next apply the gray. The gray is basically a mixture of white and black, with its shade depending on the proportions of each you use. Do the coat first. Where the lapel folds over, and on the collar and cuffs, I will use a darker color.

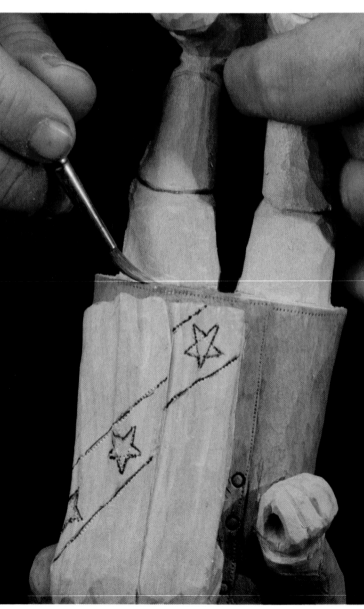

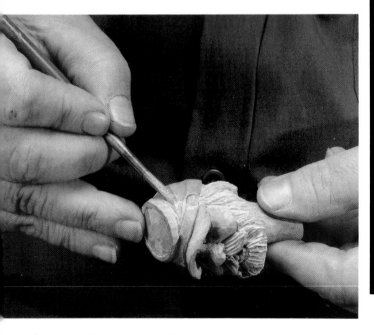

Continue the gray onto the kepi.

Before you put the grey away, paint the underside of the coat. While not normally seen, this gives the piece a sense of completion.

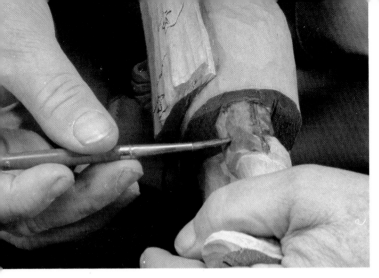

The pants will be painted blue with just a little red mixed into it.

If you get a dab of paint where you don't want it, like I did on the flag, simply use a steel eraser (knife) to remove it.

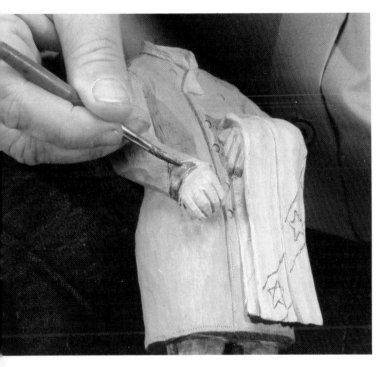

Continue the blue on the cuffs...

The blue in the flag is somewhere between a royal blue and a navy blue. Paint the blue bars.

and the folded-over lapel.

A cadmium red gives the brightness we want to the flag. Use particular care where the flag meets the uniform and where the red abuts the blue of the bars.

Come back to the blue of the uniform and paint the collar. Do the collar inside and out, however, be sure to let the paint dry before you put the head in all the way.

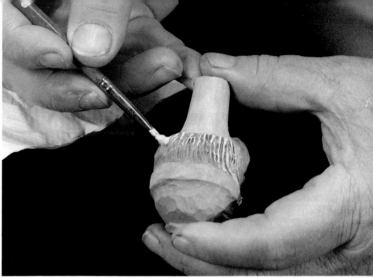

Go across the carving, depositing white pigment on the high spots. This gives the highlighting effect you are after.

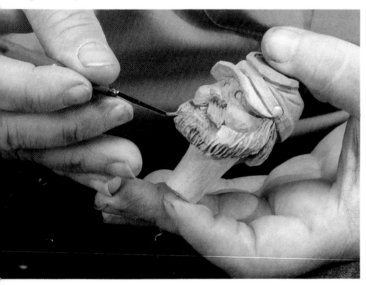

Apply a light gray undercoat to the beard, moustache, and hair.

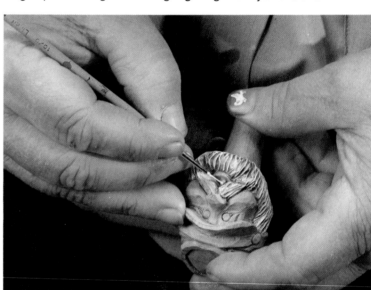

Use a very small brush to paint the tooth. I use my thumbnail as a palette for this detail work.

Dry brush over the gray with white, using a brush with the bristles cut short. By using a dry brush the pigment rests on the surface and does not go into the crevices. Use a paper towel as a palette. This will take some of the turpentine out of the paint.

Continue with the whites of the eyes.

The irises of the eyes are painted brown using a burnt sienna.

Apply black to the brim of the hat. I start underneath because it allows me to have better control over how the paint bleeds.

Use black paint from the lid of the paint jar, where the pigment is concentrated, to put a dot in the center of the eye for the pupil.

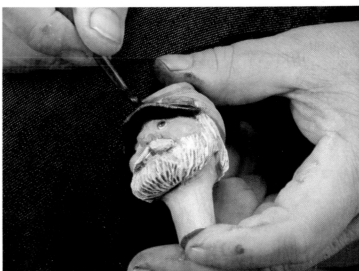

Continue with the chin strap, being careful not to paint the button.

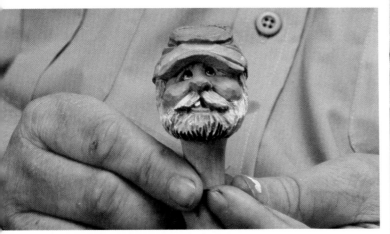

A dot of white paint on the irises brings the eyes, and the character, to life. I usually place it on the opposite side of the eye from the direction the figure is looking. Make sure the dot is in the same position in both eyes.

Paint the boots black.

Another view of painting the boots black.

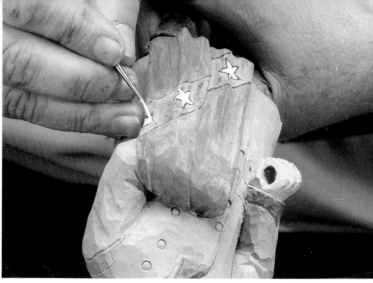

Paint the stars white.

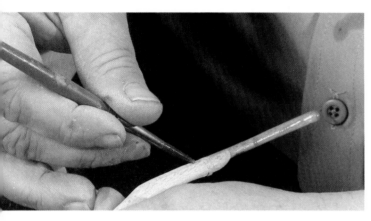

Paint the barrel of the gun using raw sienna. The color of the metal parts of the gun are difficult. You may wish to experiment some until you are satisfied with the result.

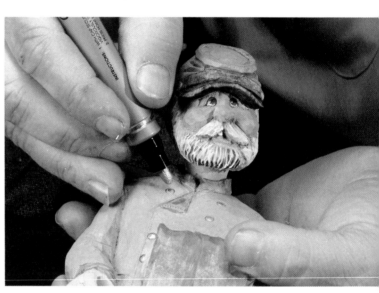

The gold buttons on the kepi and coat are done with a metallic marker, available at most art stores. While I am using a broad-tipped pen, it is recommended that you use a fine point (the store was out of them!).

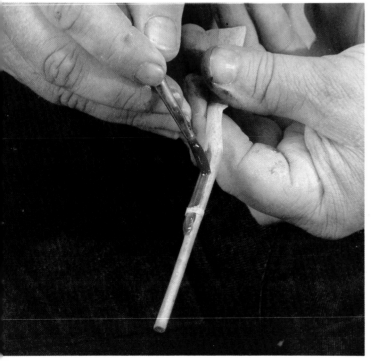

The stock of the gun in done in burnt sienna.

Put the bore in the barrel of the rifle with a black marker.

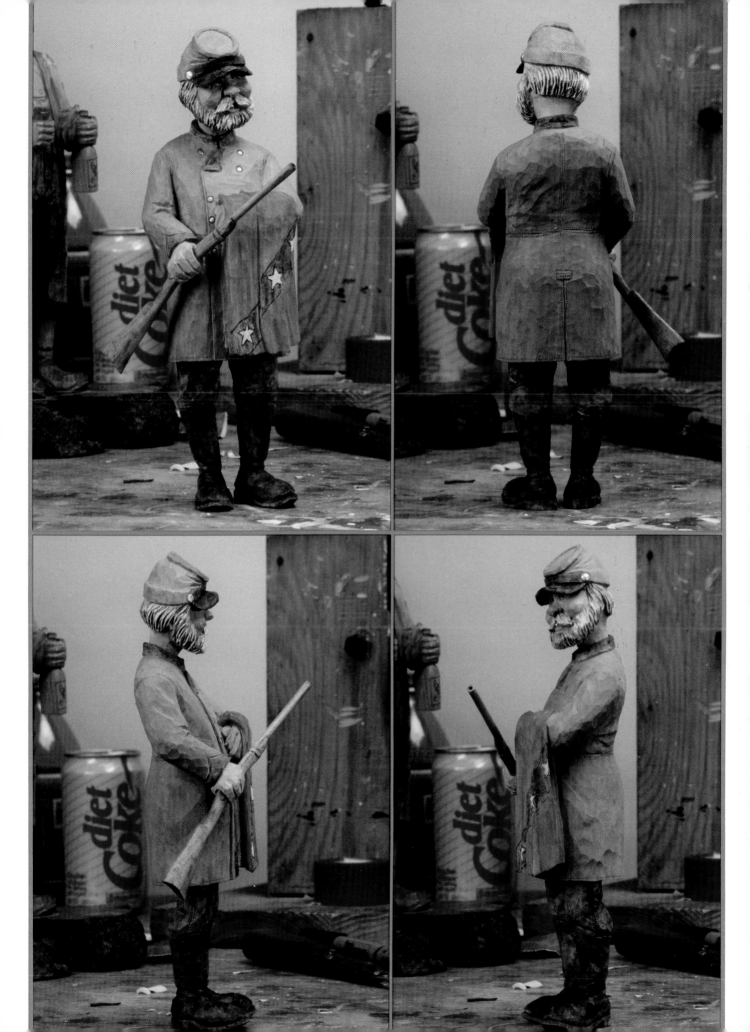

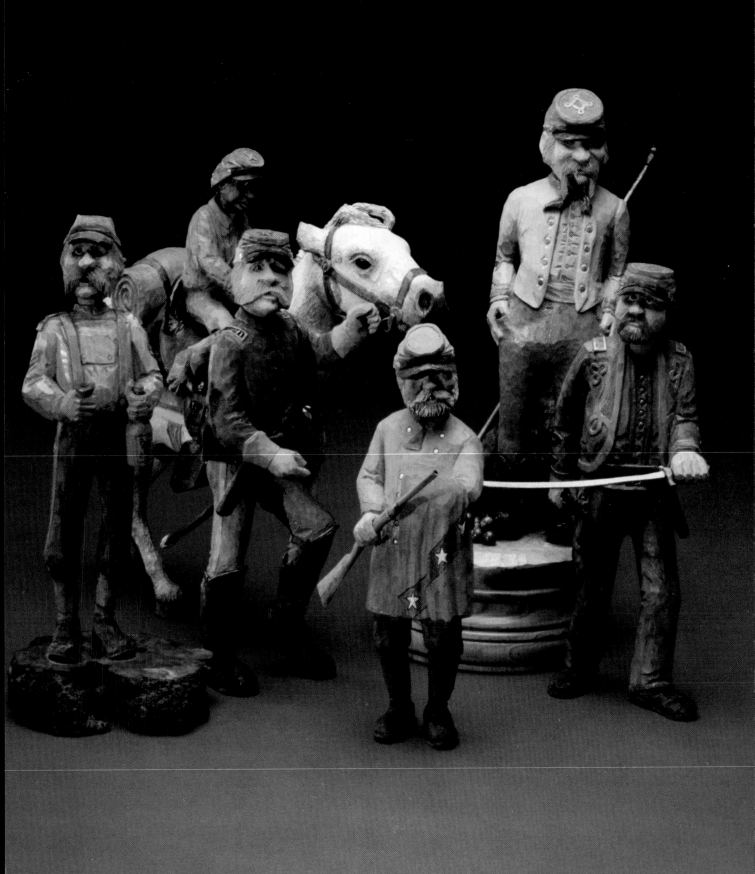

A Civil War Gallery

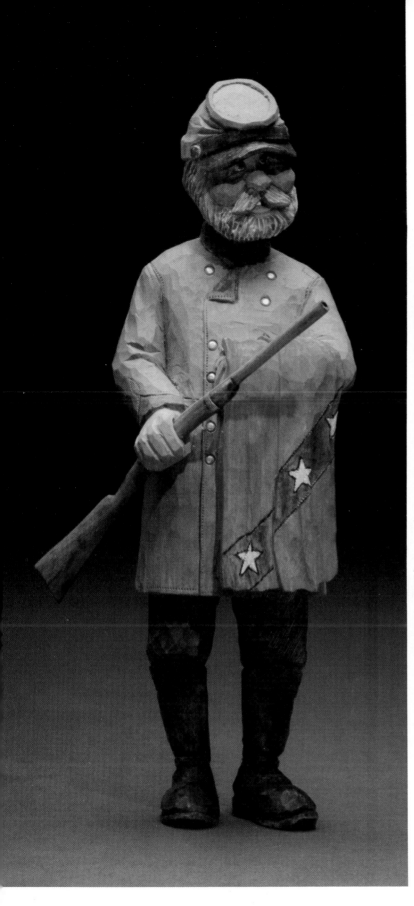
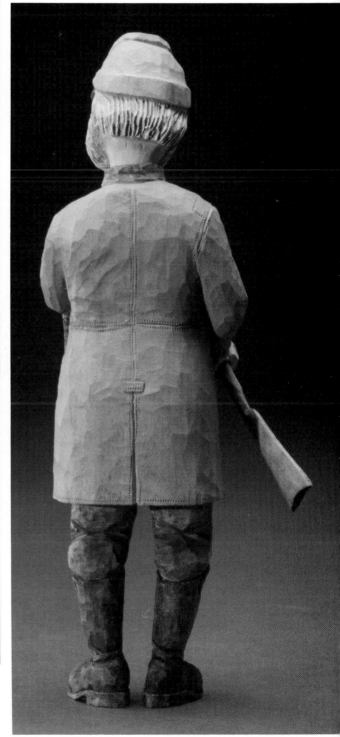

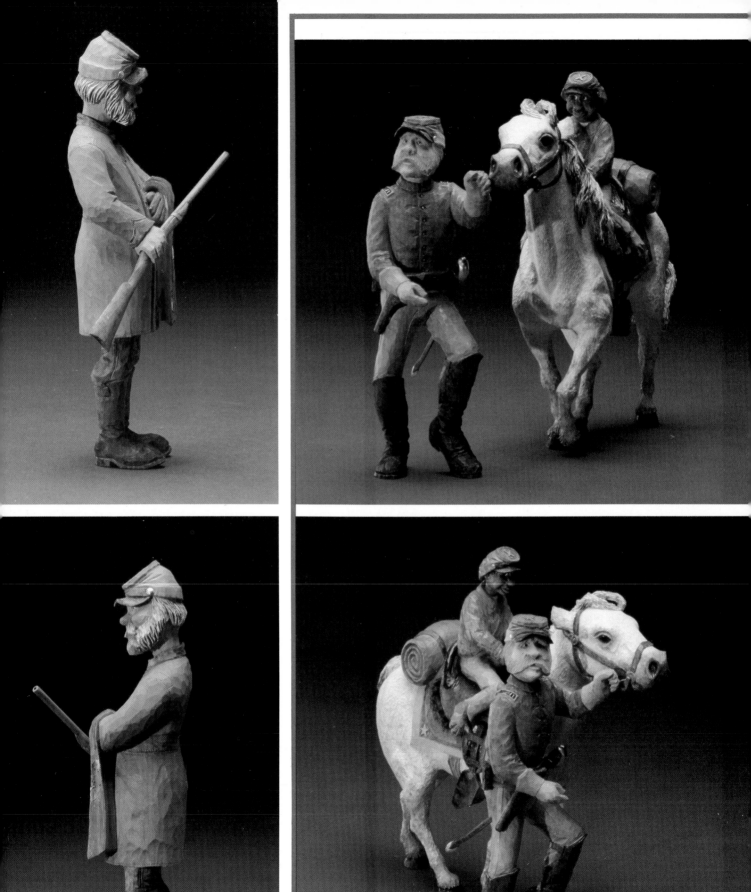

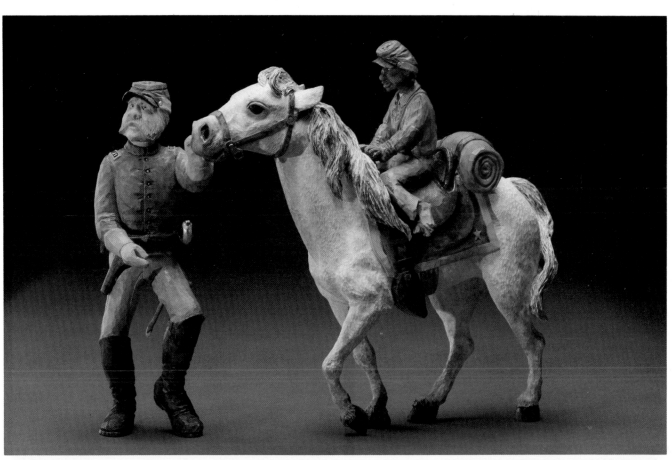

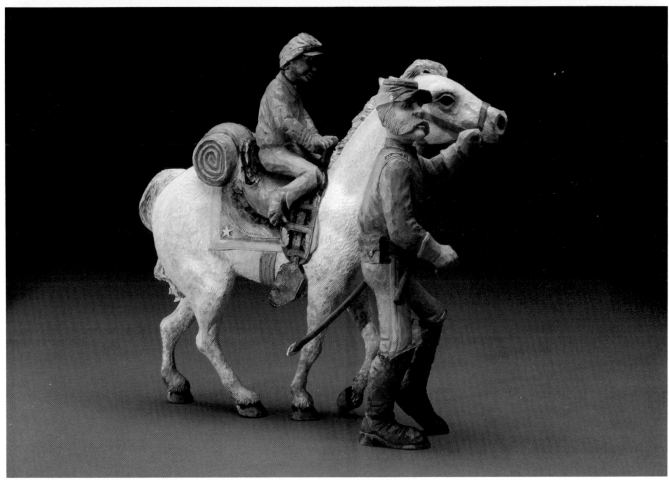

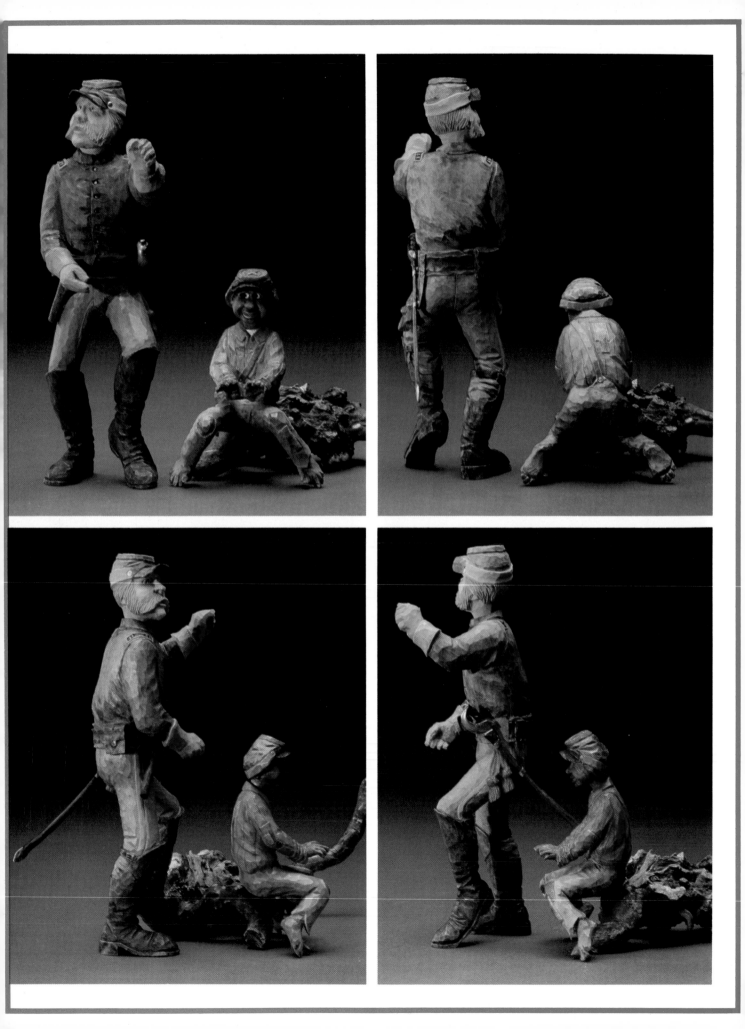

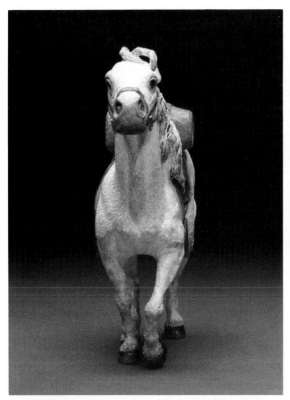
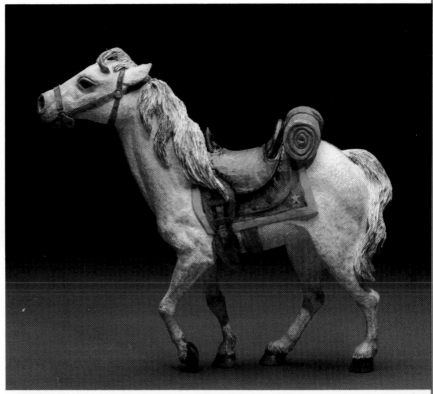
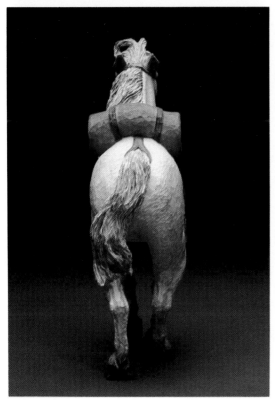
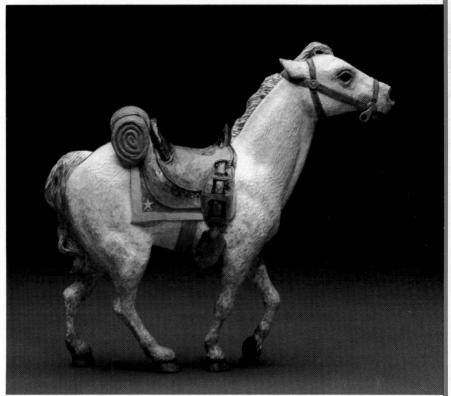

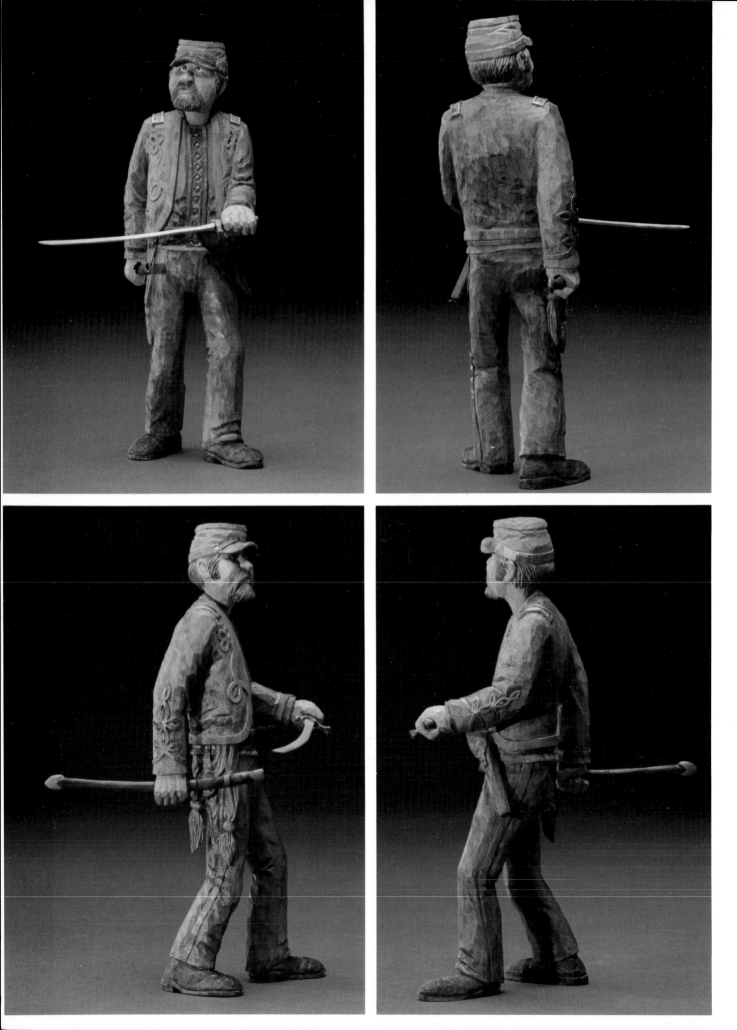

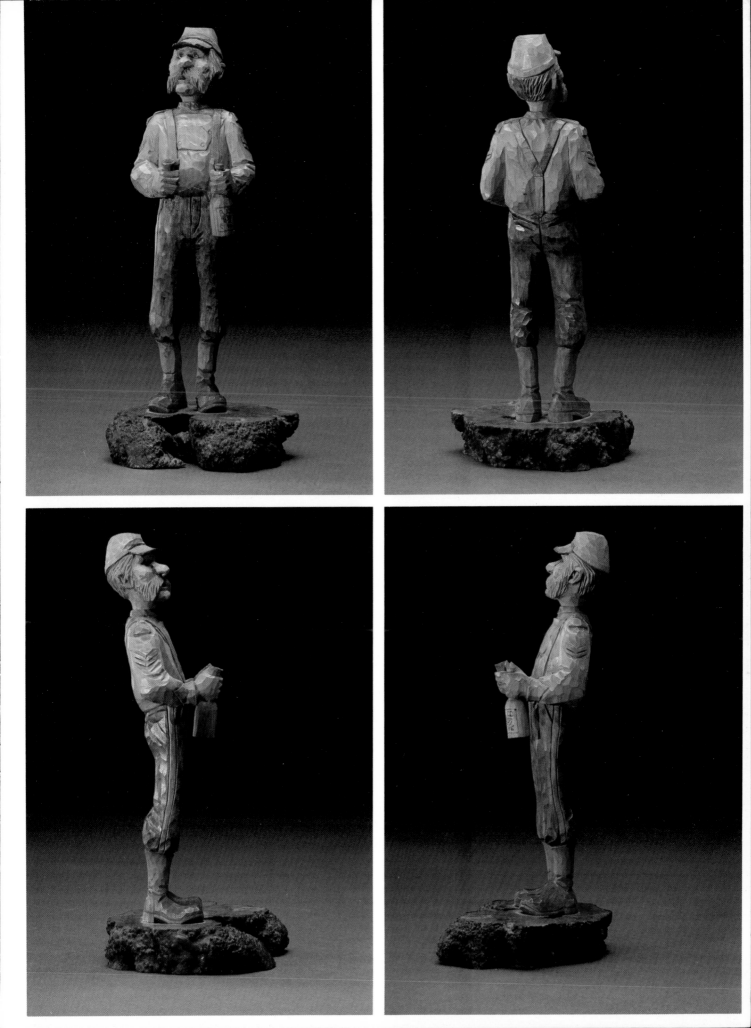

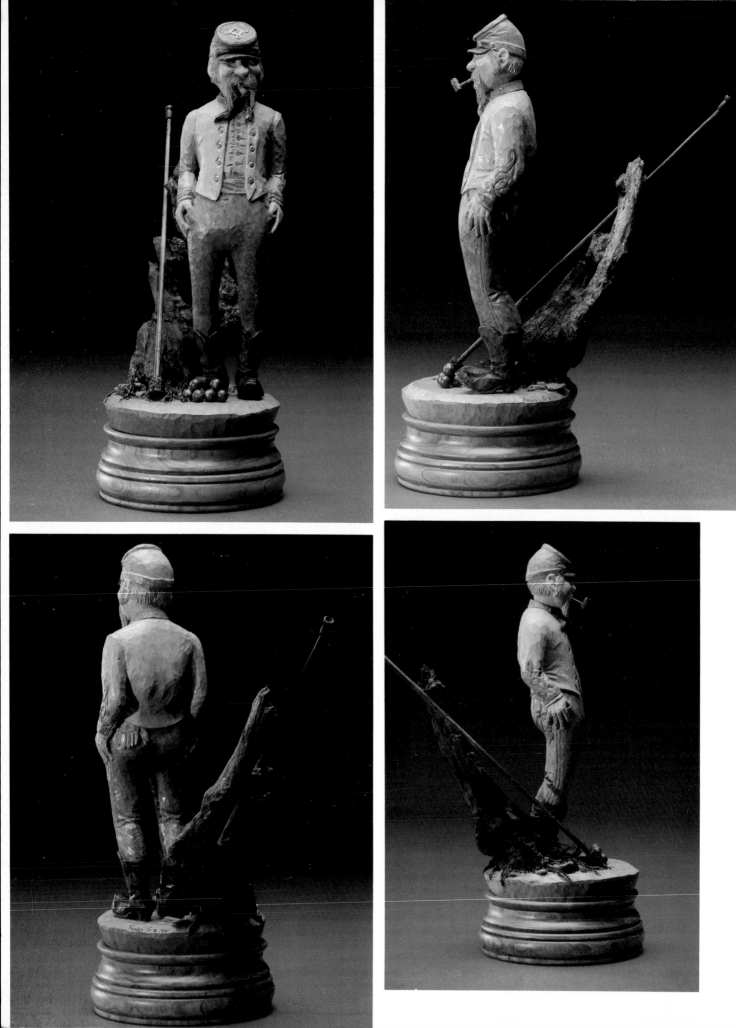